THE BEST OF
ADOBE® PHOTOSHOP®

TECHNIQUES AND IMAGES
FROM PROFESSIONAL PHOTOGRAPHERS

BILL HURTER

AMHERST MEDIA, INC. ∎ BUFFALO, NY

Copyright © 2006 by Bill Hurter.
All rights reserved.

Front cover photograph by Craig Kienast.
Back cover photograph by Jerry D.

Published by:
Amherst Media, Inc.
P.O. Box 586
Buffalo, N.Y. 14226
Fax: 716-874-4508
www.AmherstMedia.com

Publisher: Craig Alesse
Senior Editor/Production Manager: Michelle Perkins
Assistant Editor: Barbara A. Lynch-Johnt

ISBN: 1-58428-181-2
Library of Congress Card Catalog Number: 2005937362

Printed in Korea.
10 9 8 7 6 5 4 3 2 1

Notice of Disclaimer: The information contained in this book is based on the author's experience and opinions. The author and publisher will not be held liable for the use or misuse of the information in this book.

TABLE OF CONTENTS

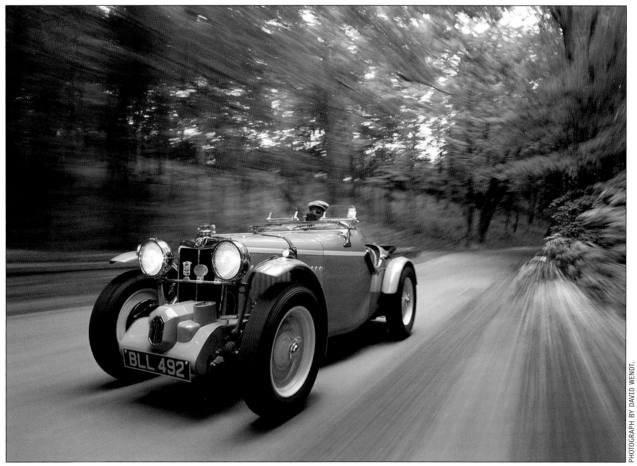

PHOTOGRAPH BY RICH NORTNIK, JR.

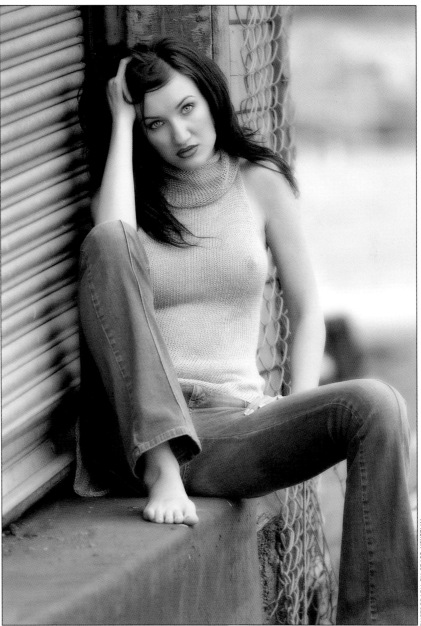

PHOTOGRAPH BY CRAIG MINIELLY.

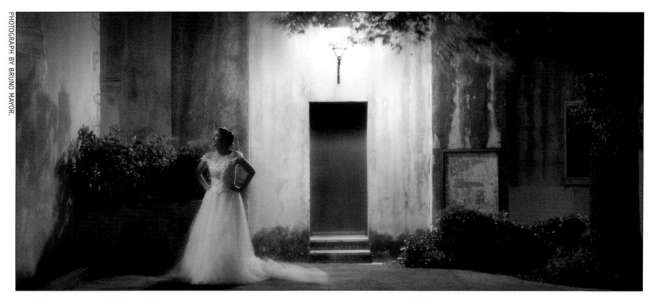

PHOTOGRAPH BY BRUNO MAYOR.

— ONE —
INTRODUCTION

"I use Photoshop as I would to hand-print an image; e.g., burning, dodging, etc. I don't use 'special effects' very often; I'm still a big fan of more traditional techniques—applied digitally, of course."—Marcus Bell

In the days leading up to the advent of digital imaging, the skeptics/realists often predicted that until a digital image could rival the amount of information found in a 35mm film frame, professional photographers would continue to ignore digital imaging. These thoughtful folks proclaimed that there are 10,000,000 discrete units of information (bits) in an exposed 24x36mm film frame. Equalling that requires a 10MB image—a file size that is now commonplace. In fact, at this writing there are a handful of professional 35mm digital SLRs that offer 16–18MB original files. Unlike film photographs,

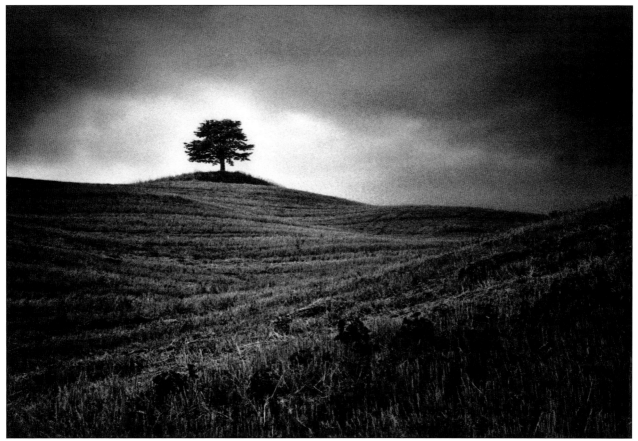

An award-winning image by Australian photographer Marcus Bell.

Hawkins, the other half of Jeff Hawkins Photography, a very successful wedding studio in Longwood, FL, the greatest benefit is "the creative control of our work." The pair has a renewed excitement for covering weddings and an appreciation for being able to view the images right away—a "powerful advantage for both photographers and clients." Photographers are no longer just recording images and sending them off to the lab for color correction, retouching, and printing. Says Kathleen, "We can now perfect our art to the fullest extent of our vision!"

In the high-style world of wedding photography, the impact of Photoshop has permanently changed the style and scope of the genre. The photographer, in the comfort of his home or studio, can now routinely accomplish special effects that could only be achieved by an expert darkroom technician in years past. Photoshop, paired with the many available plug-in filters, has made wedding photography the most creative and lucrative specialty in all of photography. And brides love it. Digital albums, assembled using Photoshop-compatible design templates, have become the preferred album type. The style and uniqueness they bring to the wedding experience make every bride and groom a celebrity.

digital images resized in Adobe Photoshop can also be made almost any size, defying the limits of size and resolution.

Adobe Photoshop has expanded the playing field for most photographers. Perhaps the greatest advantage of being a professional photographer in the digital age is creative control. According to Kathleen

The photographers featured in this book are digital artists. While they are not above using time-saving shortcuts in the image-processing side of things, they

still spend a great deal of time perfecting each image that goes out to a client. Perhaps this aspect of contemporary photography, more than any other, has accounted for the profound increase in photographic creativity. This fine-art approach, in turn, has raised the bar financially for many photographers, allowing them to charge premium prices. This is particularly true with wedding photographers who have seen the budgets for wedding photography rise for the last several years. Says wedding photographer David Beckstead, "I treat each and every image as an art piece. If you pay this much attention to the details of the final image, brides will pick up on it and often replace the word 'photographer' with the word 'artist.'"

For Connecticut's Charles and Jennifer Maring, Photoshop has opened up a wealth of creative opportunities, transporting them from being merely photographers to the status of artists and graphic designers. Their unique digital wedding albums include an array of beautifully designed pages with graphic elements that shape each page and layout. Their storytelling style is as sleekly designed as the latest issue of *Modern Bride*. The Marings not only work each image but also design each album. Says Charles, "There is a unique feeling when designing the art. I don't know what an image will look like until I am two-thirds done with it. I also don't know where the vision comes from. I relate this to the art of photography—a

higher place maybe." This talented couple believes so totally in controlling the end product that they also own a digital lab called R-Lab. "We have been totally digital for almost 10 years, and the challenge and precision of the change has actually made us better photographers than we were with film," says Charles. He believes the outside of the album is every bit as important to his upscale clients as each page therein and has been known to use covers ranging from black leather, to metal, to red iguana skin. He has even

RIGHT—David Beckstead works each image in Photoshop to produce the best possible interpretation of the moment. **NEXT TWO PAGES**—Future photographers will have to be more than just photographers, they will have to be terrific designers, as well. So says Charles Maring, who, along with his wife Jennifer and a small staff, shoot, process, design, and output all their own first-class wedding images and albums.

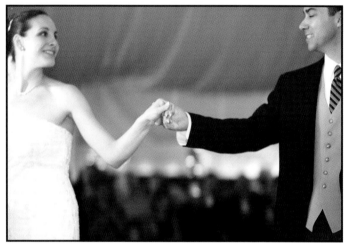

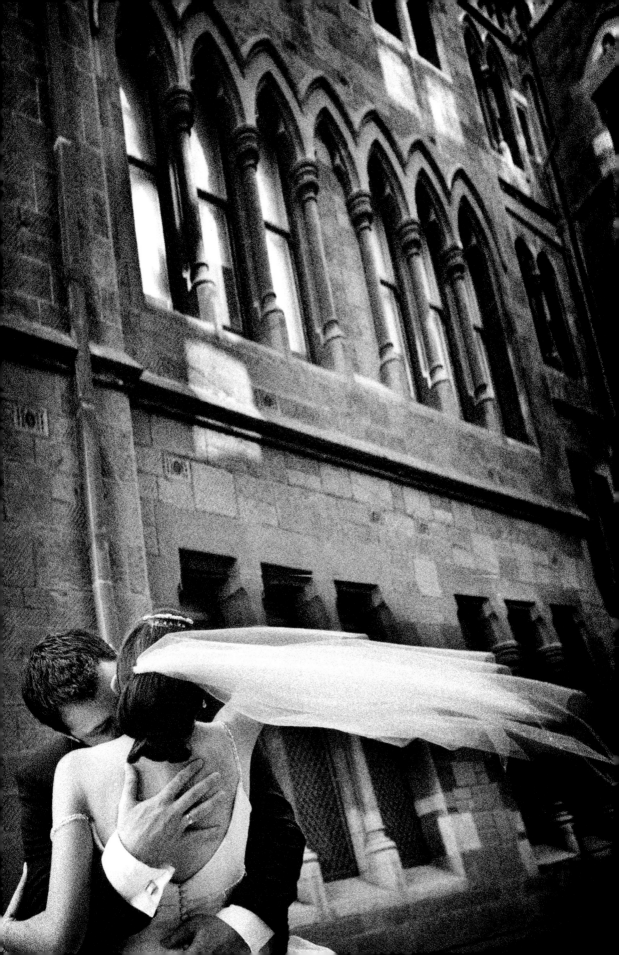

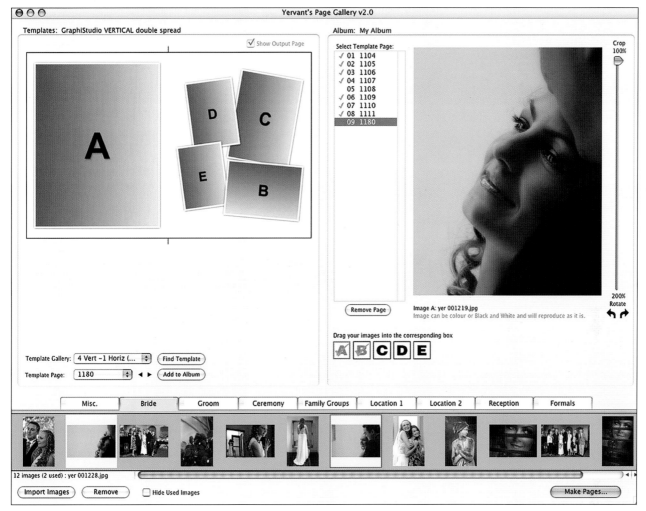

FACING PAGE—Yervant's great sense of design and flare as an imagemaker have made him one of the most sought-after wedding photographers in the world. ABOVE—Photoshop is fertile ground for nesting applications like master photographer Yervant's Page Gallery, an album-design template system that operates within Photoshop.

found a local bookbinder with his own working bindery to finish his digital albums.

Maring welcomes the technology. "The main thing that will distinguish photographers in the future will be their print- and album-design concepts," he says and notes further that, "Design is the future." Just as Photoshop has expanded the creative abilities of every photographer, those tools will also be the yardstick by which contemporary photographers will be judged. With so many creative tools available, particularly those employed by graphic designers, the successful photographer will have to raise the bar and the horizons of their own creativity.

While Photoshop is an exciting and powerful tool for crafting elegant images, Yervant Zanazanian, an award-winning Australian wedding photographer puts things in perspective: "A lot of photographers still think it is my tools (digital capture and Photoshop) that make my images what they are. They forget the fact that these are only new tools; image-making is in the eye, in the mind, and the heart of a good photographer. During all my talks and presentations, I always remind the audience that you have to be a good photographer first and that you can't expect or rely on some modern tool or technology to fix a bad image." It's good advice.

◘ Photoshop Has Replaced the Conventional Darkroom

Up until a few years ago, the image was rendered in the camera, but all the magic happened in the darkroom. There are countless great photographers who

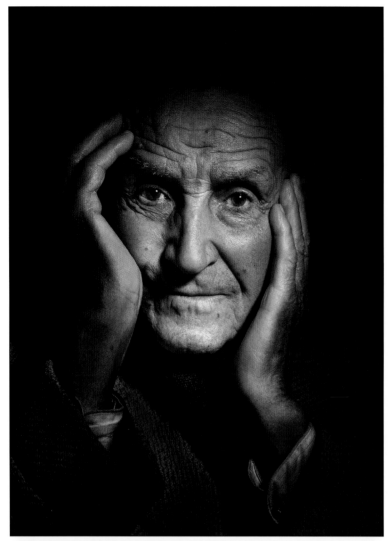

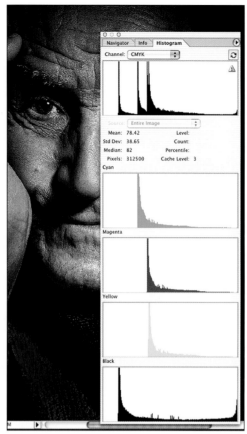

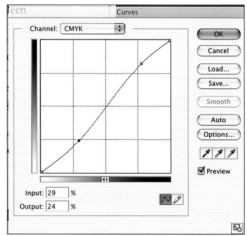

Photoshop offers many different ways to accomplish the same thing. Above are the histogram window (top) and the curves dialog box (bottom), which are both used for perfecting contrast and exposure. The histogram allows you to evaluate an image's exposure and dynamic range; these can then be adjusted using the levels or curves command. Also shown is an award-winning image by Anthony Cava (top left); it's shown the way the photographer adjusted it and blown up to 1600 percent (bottom left) to show the pixel disbursement in a very small area of the image.

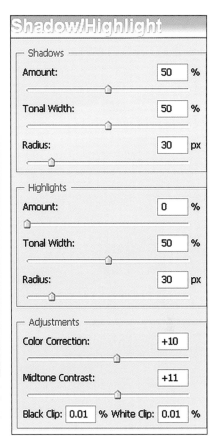

LEFT—Photoshop toolbox evolution as it has progressed over the years (from left to right: versions 2.5, 3, 4, 5, 5.5, 6, 7, CS, and CS2). **RIGHT**—The shadow/highlight menu is another means to make quick corrections to images that are difficult to correct because of inequities in the shadows, highlights, or both.

tell of becoming "hooked" on photography when they first saw a print emerging in the safelight gloom of the developer tray. And who can forget learning to load 35mm film onto stainless steel reels? It was a badge of courage that made learning the basics of photography seem more rewarding than a post-graduate degree.

Printing and developing techniques have not disappeared, but they have been rolled into Photoshop with tools that mimic conventional photographic techniques. Literally everything you could do in the darkroom, except getting brown hypo stains on your clothes and fingernails, can be done in Photoshop—and done better and more extensively.

The designers of Photoshop could have used any frame of reference on which to build the application—mathematical or scientific, for example. But they chose photography as the medium that provided the most useful language and logic of image enhancement. And they borrowed heavily from the science of photography. Burning, dodging, cropping, curves, shadow and highlight control, and many

other functions are all part of day-to-day operations with Photoshop, just as they are part of the conventional photographic lexicon.

Photoshop is one of the great technological innovations of this or any other era. The application is so richly layered that users find many different ways to achieve the same or similar effects. As a result, many of the effects displayed by the artists in this book are the result of an intuitive approach to solving a specific imaging problem in Photoshop.

This book is not another how-to manual on using Photoshop. There are already many such books on the market. Instead, this book is about those who use Photoshop as a mainstay in their digital-imaging business—the work of artists, illustrators, commercial photographers, album designers, wedding photographers, portrait photographers, teachers, and a few unclassified professionals will be presented here. It is my hope that you will learn from their innovative and often totally original uses of Photoshop.

Thanks go out to all those who helped in the preparation of this book, in particular: Claude Jodoin

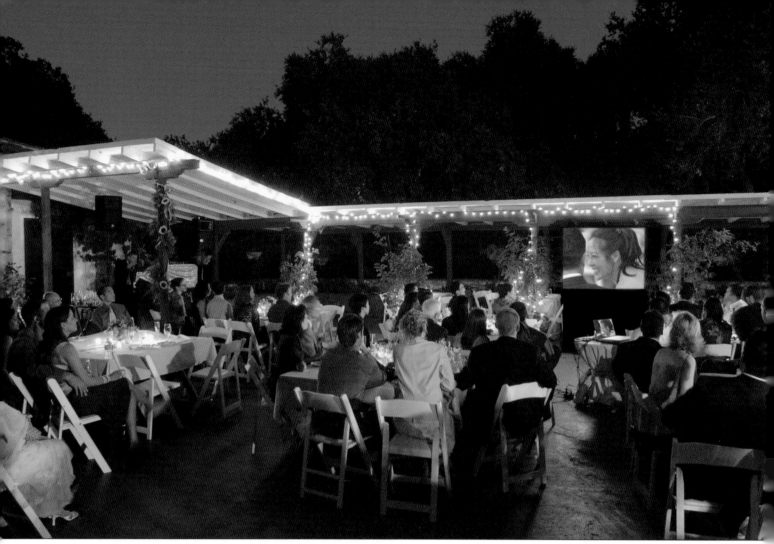

Mike Colon is a well-known Southern California wedding photographer who uses Nikon DSLRs and their WiFi technology to download images to a laptop as they are recorded throughout the wedding day. Mike's assistant preps the images and then saves them into a slide-show program so that guests just entering the reception are treated to a display of the images made throughout the day. The power of digital imaging has transformed the wedding day into a multimedia event.

(a.k.a., Professor Pixel); Rich Nortnik, Jr.; Jerry D (who has patiently walked me through numerous complex Photoshop procedures); Craig Kienast; Craig Minielly (a.k.a. Craig's Actions); Yervant; Charles Maring; and all of the other gifted photographers and artists who appear in this book. Without them, it would not have been possible.

— TWO —
GOOD DIGITAL
WORKING TECHNIQUES

Working with digital files is very different than working with film. For one thing, the exposure latitude, particularly when it comes to overexposure, is almost nonexistent. Some photographers liken shooting digital, especially in the JPEG file format, to shooting transparency film; it is unforgiving in terms of exposure.

The upside of this seeming flaw in the process is that greater care taken in creating a proper exposure only makes you a better photographer. But for those used to the ±2 stops of exposure latitude common in today's color-negative films, this is a different ball game altogether.

Proper exposure is essential because it determines the dynamic range of tones, the overall quality of the image, and is one of the key factors determining the quality of the final output from your digital file. Underexposed digital files tend to have an excessive amount of noise; overexposed files lack detail and tone in the highlights.

According to Claude Jodoin, an acclaimed wedding photographer and digital expert from Detroit, MI, "Your days of overexposing are over! Kiss them goodbye. You must either be right on with your exposures or, if you make an error, let it be only slightly underexposed, which is survivable. Otherwise you will be giving refunds to your clients. Overexposure of any kind is death with digital."

These are strong words to be sure, but with digital capture you really must guarantee that the dynamic range of the processed image fits that of the materials you will use to exhibit the image (i.e., the printing paper and ink or photographic paper).

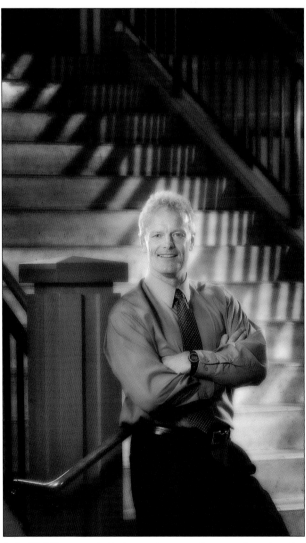

Craig Minielly created this impressive executive portrait on location and then enhanced it using his own actions (Actions by Craig) in Photoshop. The actions used were: Facial Enhancements, Porcelain-Skin, DarkEdge Strong, Fashionizers Strong, and UnsharpMask Medium. Selective darkening was applied around the subject with local lightening on the subject. The effects diffuse the overall values in the image and enhance the edge-lighting effects. Also, the facial details have been enhanced.

Photographer John Lund has a lucrative career, with a little help from Adobe Photoshop, making hilarious images of dogs and cats doing things humans like to do but with a bit of a twist. His line of greeting cards, "Animal Antics," published by Portal Publications, features these amusing cats and dogs lounging in swimming pools, doing the tango, having their hair done, and even practicing the sport of sumo wrestling. His photographs can be seen on everything from greeting cards to posters, calendars, jigsaw puzzles, and stationery.

Creating the cards is a team effort. Every few months, Lund meets with the creative team from his card company

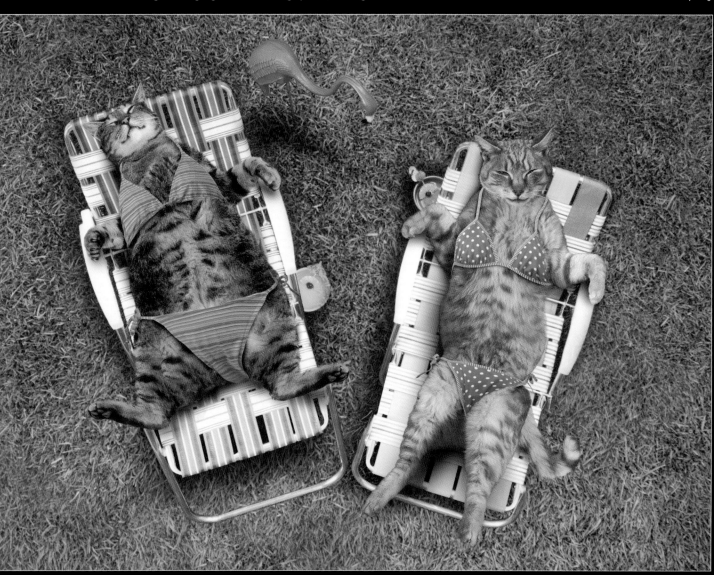

John Lund and team shot the sod in the studio with the lawn chairs and flamingo on it. The bathing suits were shot on a mannequin with a Hasselblad. He used a combination of Live Picture and Photoshop for the compositing and retouching.

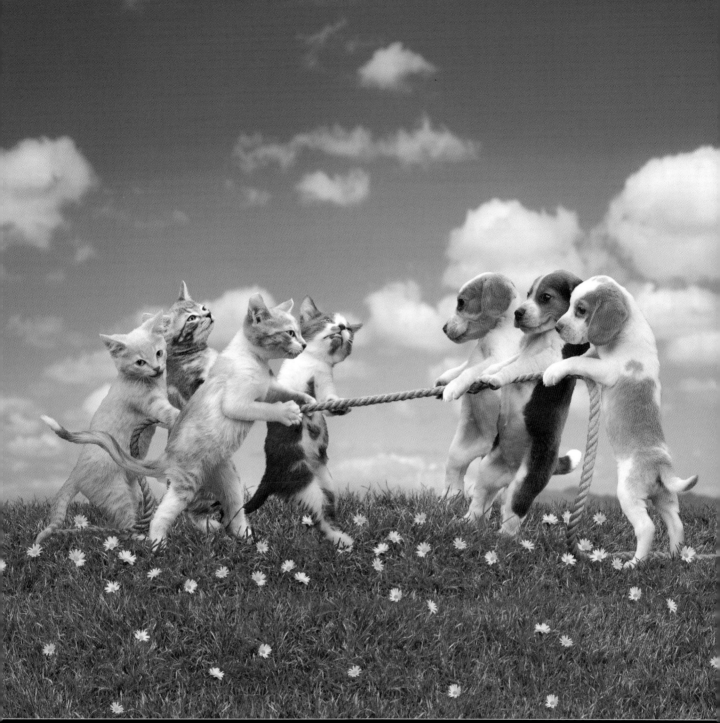

The sky was shot with a Fuji 617 Panorama Camera on E100 film. John used a Canon 1DS to shoot the sod, puppies, kittens, and rope in the studio. Switching to digital capture has significantly reduced the time it takes to produce each image. Composited in Photoshop.

and they come up with 10 to 12 new card ideas for Lund to shoot. They give him layouts and copy and he usually complains, asking, "How am I going to do that?" Then he does the images and they usually come out remarkably similar to the layouts. It takes Lund two to three months to create about a dozen images.

John works with an animal trainer and shoots animal

each image together later. He also works with a stylist who helps coordinate locations and props. Then he puts all the images together using Photoshop. It takes Lund about a day of imaging to complete each one.

Lund uses Photoshop for everything. He uses Photoshop's file browser and three different monitors. He puts tools on one, the image in the center, and the browser on

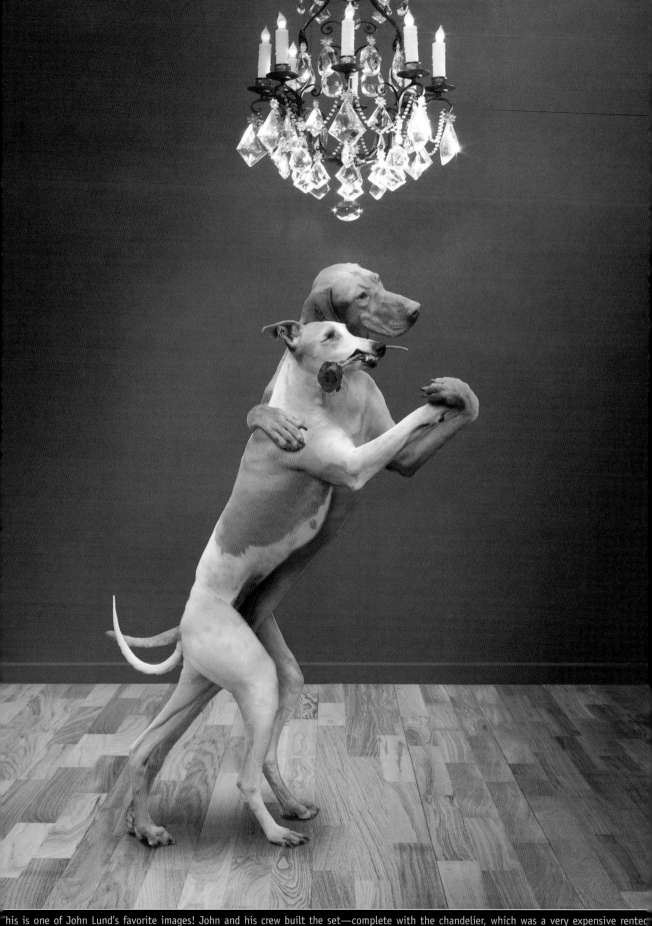

his is one of John Lund's favorite images! John and his crew built the set—complete with the chandelier, which was a very expensive rentec ntique. The wood floor was Pergo flooring. The dog with the rose in her mouth is a whippet, who had been rescued and was sweet but very nerv

reviews all the different parts and quickly pulls them up, strips them out, and drops them into the composite. Lund employs a cadre of Apple computers, including several G4s and G5s. He uses all flat screens now because, he says, "They look cool."

In both the photography phase and the compositing process, Lund's major challenge is to make the animals look natural and not weird when depicted doing human-like actions. For instance, there is no template for the appearance of a cat holding a toothbrush—it's not something normal. Having the comps to work from when photographing the animals helps him solve the problem of making the animals create a movement that is unnatural to them. Lund, an animal lover, makes certain that none of his posing irritates the animals.

After 27 years, John Lund really loves what he does—and it's not just the financial rewards. People are constantly telling him that his work put a smile on their face, as he was told by a young woman not long after the 9/11 tragedy. His latest book is *Adobe Masterclass Photoshop Compositing with John Lund* (Peachpit Press, 2004). His other very popular books include *Animal Antics* and *Animal Wisdom* (Andrews McMeel, 2004). His website is www.johnlund.com.

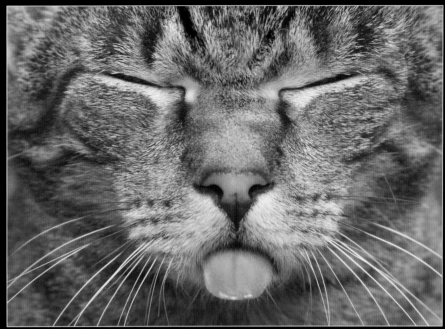

The face, tongue, and eyes were all separate shots. To get images like this requires a lot of patience and great timing; cats don't shut their eyes that often—at least not while they are in front of a camera with strobes, assistants, other cats, art directors, and an animal trainer nearby! John Lund shot this image with a Canon 1DS. Photoshop was used for compositing and retouching.

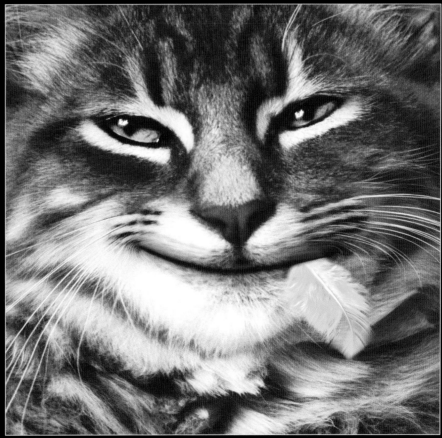

This image started it all when John presented it to Portal Publications with the idea of doing a line of animal cards. The cat (actually a kitten) was shot on Kodak E100 film with a Nikon F100. The feather was captured with a Leaf DCBI digital back.

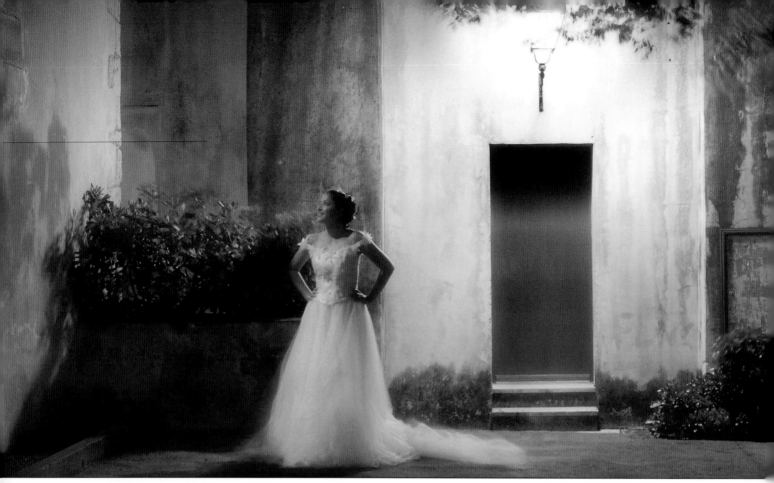

ABOVE AND FACING PAGE—Frenchman Bruno Mayor often tweaks the white balance in his images to reflect either accurate color and flesh tones (vertical image) or completely inaccurate, fun-house colors and skin tones (horizontal). Either way, brides and other photographers seem to love his work.

◻ Determining Your Camera's E.I. (Exposure Index)

Not all digital cameras are created equal. Just as in all things man-made, there are manufacturing and production tolerances that make complex electronic devices dissimilar. It is important to know that your camera's metering system, on which you will rely heavily, is faster or slower than its rated film speed (ISO) index.

Here's an adaptation of a simple test that technical whiz Don Emmerich came up with using an 18-percent gray card. A Kodak gray card is 18-percent gray—precisely midway between black and white. Light meters "see" in terms of 18-percent gray. Fill the frame with the 18-percent gray card and meter the scene with the in-camera meter. Expose exactly as the meter indicates and view the histogram.

If the exposure is correct, there will be a single spike dead center in the histogram, and you will know that the camera is giving you a true, rated ISO. If the spike is to the right or left of center, adjust the camera's ISO setting by ⅓ or ½ stop and try again. If, for example, your initial test was made with an ISO of 400 and the spike on the histogram is slightly to the left of center, it means the shot is slightly underexposed, so adjust the ISO setting to E.I. 320 or E.I. 250 and make another frame and review that histogram. If the spike is to the right of center, the frame is overexposed and you will have to reduce the exposure by setting the ISO to ⅓ or ½ stop higher; e.g., E.I. 500 or E.I. 620. Once the spike is properly in the middle of the histogram, you have a perfect exposure for this particular lighting.

So how do you apply what you've learned? If you repeat this test at different ISOs and under different lighting conditions, you should come up with a reliable factor. Or you may find your meter is perfectly accurate. If, however, you find that the meter is consistently underexposing frames by ⅓ stop, add +⅓ stop of exposure compensation. If, on the other hand, the meter is consistently overexposing by ⅓

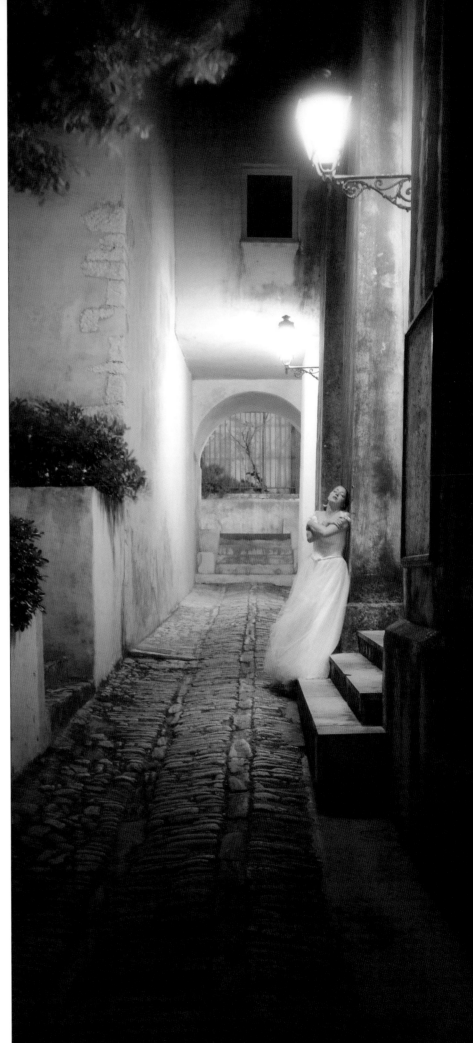

stop, dial in –⅓ stop of exposure compensation or adjust your ISO setting accordingly.

Perform this same series of tests with your handheld incident meter to make sure all the meters in your arsenal are precisely accurate.

■ Metering

With advances in multi-pattern metering, in-camera metering has been vastly improved. However, one must still recognize those situations when a predominance of light or dark tones will unduly influence the meter reading and subsequent exposure.

For this reason, the preferred type of meter is the handheld digital incident-light meter, which measures light in small units—tenths of a stop. This

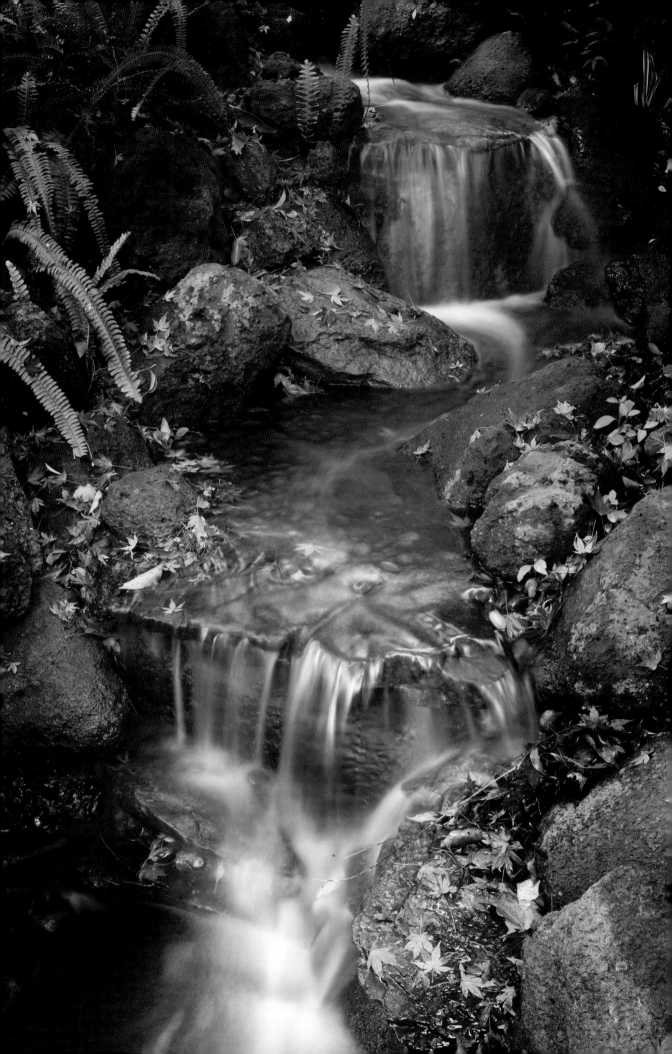

type of meter does not measure the *reflectance* of the subjects, but rather it measures the amount of light *falling on* the scene. This type of meter yields extremely consistent results, because it is less likely to be influenced by highly reflective or light-absorbing surfaces, like white dresses or black tuxedos.

Simply stand where you want your subjects to be, point the meter's dome at the camera lens, and take a reading. (When using an incident meter in a situation where you can't physically get to your subject's position to take a reading, you can meter the light at your location if it is the same as the lighting at the subject position.)

There is another school of thought on where to point an incident meter. Some photographers recommend pointing it at the light source, not the lens.

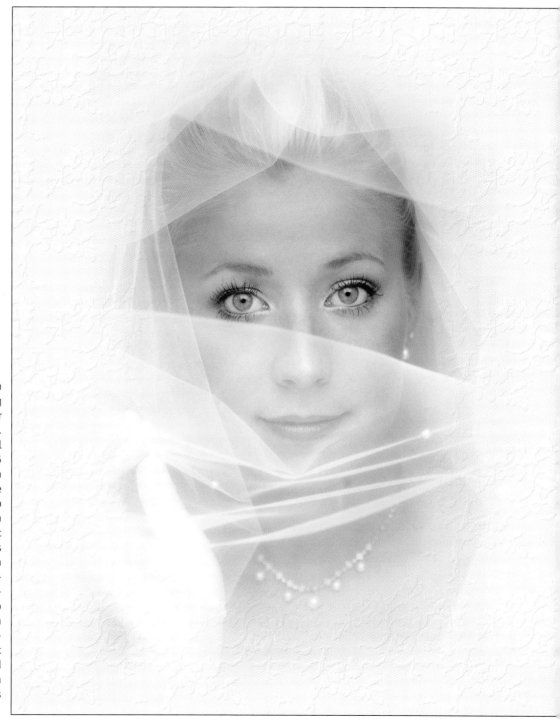

FACING PAGE—Ray Prevost is an outdoorsman first and wedding photographer second. He never hikes or skis without his camera. Here, he discovered a beautiful scene, which he documented at 2.5 seconds at f/18. The blurred stream looks almost like cotton candy. He tweaked the file later in Photoshop by adjusting various layers to open up shadow areas and even out highlights. The result is a fabulous image. **RIGHT**—Ray Prevost is an accomplished wedding photographer who shoots RAW files at weddings, primarily for backup and to have the most data available from his digital files. He shot this wedding portrait with a wall of soft available light behind him and later combined the image with a vignette of the wedding dress material.

For over 25 years Jim DiVitale has been involved with multiple imagery, combining images with pin-registration and now digitally. As an advertising photographer working for Coca-Cola, he learned how to mask one background and insert another or take the bubbles from one drink shot and combine them in another image.

According to DiVitale, "The talent that has to be sharpened in an advertising photographer is previsualization. I can look at a layout or be given a word and see a finished picture in my head. I can see exactly where every detail goes. Whether it is multiple layers or a single image, I know how to draw a straight line to get to the end result in the least amount of time."

Having grown up with 8x10-format cameras and film, DiVitale is completely comfortable with digital capture. DiVitale espouses the use of RAW file imaging and brags that he can take a 2MB file and blow it up to 500MB. "If you know how to do it right, it works perfectly," he says.

He also believes that most digital shooters don't quite get the idea of RAW files. They start shooting JPEGs for speed and when they blow things up, the images fall apart because there's no data there. DiVitale makes Duratrans transparencies, trade show displays, and large-scale images as big as 40-feet long. You just have to know the right techniques in Photoshop—either step interpolation or a third-party interpolating program.

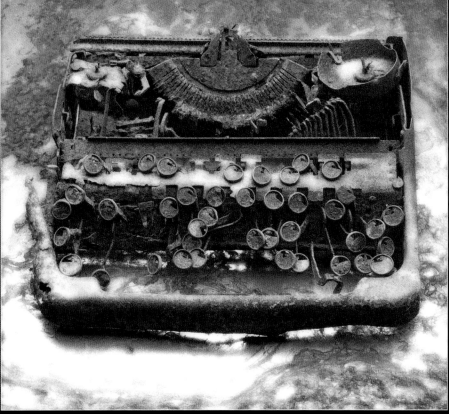

This typewriter was spotted sticking up from the ground in the woods by a friend. It was photographed on a rusty metal background with one small softbox positioned from behind and a fill card up front. The camera was a Leaf DCB camera back on a Fuji GX-680 camera body with an 80mm f/5.6 lens. The diffused glow filter (Filter>Distort) was added in Photoshop to give it the grainy appearance. The resulting image portrays battle-worn technology and won First Place Digital Capture: Personal Work in *Photo District News'* Digital PIX Awards Annual.

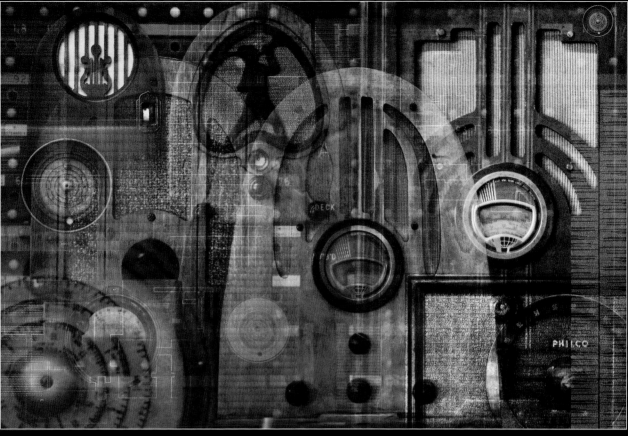

ABOVE—About this photographic montage, *Radio Wars,* DiVitale says, "The most important talent to develop for an illustrative photographer in the digital age is previsualization. Being able to see images in mutable layers takes this creative process to the next level."

While on a Photoshop lecture tour, DiVitale stayed a few nights on the Queen Mary in Long Beach, CA. While wandering around on the ship with his camera, he found a display room with antique radios. "The room was very dark, and I didn't have a tripod with me, so I raised the ISO to 800 and set the white balance for tungsten. I pressed the lens right up to the glass window to brace the camera and shot one-second exposures of the different radios in the room as RAW files. The files were then processed in Photoshop's Adobe Camera RAW.

Using the old telephone line switchboard as a background anchor layer, he outlined each of the radios with the pen tool, turned them into selections, and brought them into the image as layers, one image at a time. He then blended the different radio images together using different layer modes and opacities. Some of the layers were duplicated a few times with different combinations of blend modes to get the translucent effect. Additional tiny grid lines and type were added with different blend modes for added image depth.

RIGHT—The hand was originally photographed for a promo directory. It was shot on 4x5 Kodak transparency film on a Horseman 450 EX camera with the Hosemaster lighting system and scanned into Photoshop for a few minor adjustments. It was then used as a self-promotional poster.

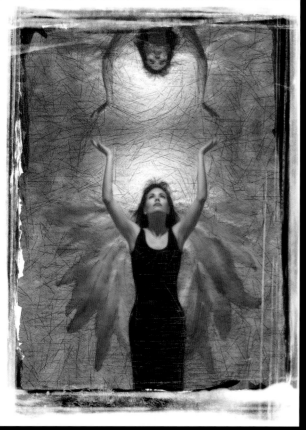

LEFT—The angel was originally photographed for an Atlanta magazine cover and redone 10 years later for a *Photoshop User* cover story. The feather wings were shot as a still life on glass with light coming up from behind. The angel and wings were put together in layers in Photoshop. A flat version was opened in a painting program called Studio Artist and some additional brush strokes were added. The image was run through an Extensis Photo Frame plug-in for the final edge effects.

BELOW—Jim DiVitale's background as a commercial photographer is evident in this exquisite still life of golden apples. The elegant lighting, delicate shading, and use of grain effects make this image a modern masterpiece. The image was shot by the light of a desk lamp in a hotel room in Rome. It was brought into Photoshop for a little selective focus and grain treatment. The edge was then added in Photoshop with Extensis Photo Frame plug-in.

FACING PAGE—This was a self-promotional ad that Jim DiVitale worked on with a designer for a creative awards annual. All the elements, including each single flower, were shot separately and combined in layers with some custom artwork in Adobe Illustrator.

DiVitale

digital photography and
computer photo illustration

OPEN
TO
INTERPRETATION

Atlanta 404.350.7888

www.DiVitalePhoto.com

LEFT—On the way up the California coast to speak at the San Francisco Academy of Art, DiVitale stopped for a break at the San Miguel Mission. He shot a dozen images with the Fuji Finepix S2 Pro using a 24–120mm f/3.5–5.6G ED-IF AF-S VR Zoom-Nikkor lens. He later brought several images together in Photoshop as layers using different blending modes and opacities. To complete this montage he added some additional type from his library of digital images.

BELOW—This composite was made with several images shot with a 35mm Canon F-1 on Kodak transparency film. Layers were merged into Photoshop. A flat version was processed in Studio Artist with several different painting effects. Each "save as" became a separate file. All the new painting files were then opened up in Photoshop and blended together with layer masks and layer blending modes with the original composite.

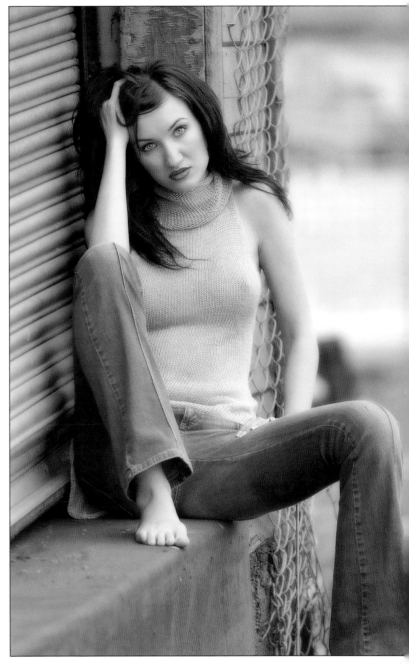

ABOVE—Claude Jodoin shows how effective the shadow/highlight control in Photoshop can be in reviving an underexposed JPEG. RIGHT—Craig Minielly created this outdoor portrait with natural daylight and later enhanced the image using his own actions, Craig's Actions (see page 74). The actions used were: Portrait Popper Light, Facial Enhancements, PorcelainSkin (opacity at 60 percent; subject details were brushed back in). All of Craig's originals are captured in RAW mode so that he can preserve the optimum amount of color data in the original file.

Sometimes there is no difference in the readings, but sometimes there is up to ½ stop difference, which can make a difference in digital exposures. It is advisable to get into the habit of metering both ways. Make two test exposures at the different settings and view them on the LCD to see which is more accurate.

If you base the majority of your exposures on its data, it is advisable to run periodic checks on your meter. You should do the same with any in-camera meters you use frequently. If your incident meter is also a flashmeter, you should check it against a sec-ond meter to verify its accuracy. Like all mechanical instruments, meters can become temporarily out of whack and need periodic adjustment.

◼ White Balance

White balance is the camera's ability to correct color when shooting under a variety of different lighting conditions, including daylight, strobe, tungsten, flu-orescent, and mixed lighting.

DSLRs have a variety of white-balance presets, such as daylight, incandescent, and fluorescent. Some

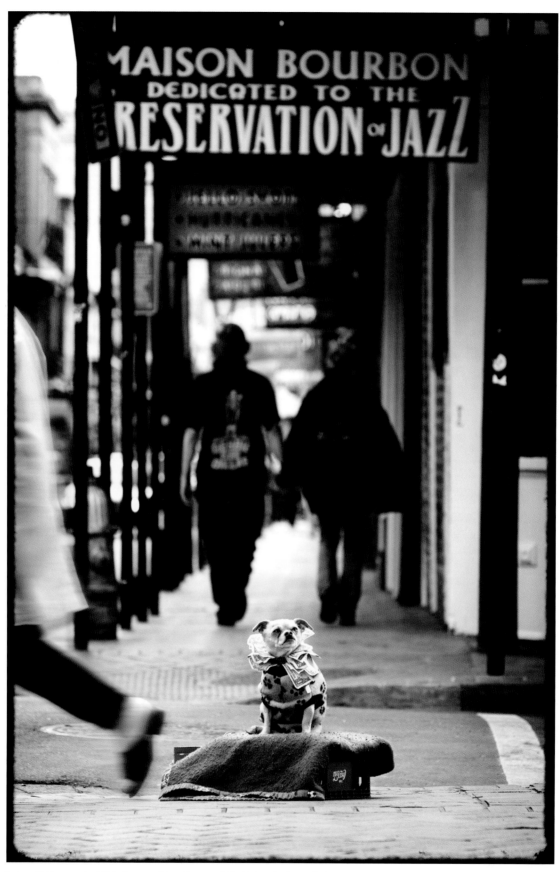

Parker Pfister created this image with a Canon 1D Mark II. His lens of choice was a Canon 24–70mm f/2.8 IS-L. The image was captured in RAW mode and converted in Capture One Pro software. This allowed him to retrieve as much information as possible. Parker feels that the combination of the Mark II in RAW mode and the extremely sharp Canon optics give depth and realness to the images. This image was part of his New Orleans series. As a fine wedding photographer, his reflexes and storytelling skills are extremely sharp.

also allow you to dial in specific color temperatures in Kelvin degrees. These are often related to a time of day. For example, pre-sunrise might call for a white balance setting of 2000°K; heavy overcast might call for a white-balance setting of 8000°K.

Most DSLRs also let you create a custom white-balance setting, which is essential in mixed-light conditions, most indoor available-light situations, and with studio strobes. A system many photographers follow is to take a custom white-balance reading of a scene where they are unsure of the lighting mix. By selecting a white area of the scene or subject and neutralizing it with custom white balance, you can be assured of a fairly accurate rendition.

Other pros swear by the Wallace ExpoDisc (www .expodisc.com), which attaches to the front of the lens like a filter. You take a white-balance reading with the disc in place and the lens pointed at your scene. It is highly accurate in most situations and can also be used to take exposure readings.

Achieving a correct white balance is particularly important if you are shooting highest-quality JPEG files. It is not as important if you are shooting in the RAW file mode, since these files contain more data than the compressed JPEG files and are easily remedied later.

◼ Evaluating Exposure

There are two ways of evaluating the exposure of the captured image: by judging the histogram and by evaluating the image on the camera's LCD screen. The more reliable of the two is the histogram, but

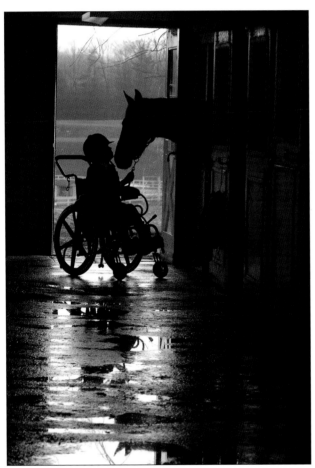 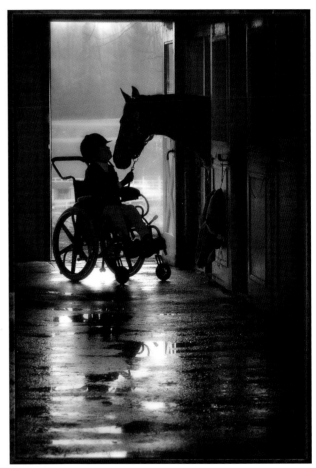

ABOVE—Craig Minielly captured this original image without any auxiliary light. The silhouette is nearly void of detail, making the image difficult to read. Minielly shoots his original images with the camera tone set to low, all sharpening off, and the exposure set to retain detail in the highlights. **RIGHT**—Here, Craig Minielly used some of his own actions to lower the contrast, add some glow, and thus improve the detail so that the moment is better served. Actions used include: Portrait-PopperWarm, ShadowSoft Natural, and DarkEdge Strong. Selective darkening was also applied around the subject and bright areas with local lightening in the shadows, water, and on the subject. With diffusion and local lightening in the shadows, the image has more detail and therefore communicates better.

the LCD monitor provides a quick visual reference for making sure things are okay in terms of the sharpness and exposure of the shot.

The histogram is a graph that indicates the number of pixels that exist for each brightness level. The range of the histogram represents 0–255 from left to right, with 0 indicating "absolute" black and 255 indicating "absolute" white. Histograms are scene-dependent. In other words, the number of data points in the shadows and highlights will directly relate to the individual subject and how it is illuminated and captured.

In an image with a good range of tones, the histogram will fill the length of the graph (i.e., it will have detailed shadows and highlights and everything in between). When an exposure has detailed highlights, these will fall in the 235–245 range; when an image has detailed blacks, these will fall in the 15–30 range (RGB mode). The histogram may show detail throughout (from 0–255), but it will trail off on either end of the graph.

THE HISTOGRAM ALSO GIVES AN OVERALL VIEW OF THE TONAL RANGE AND "KEY" OF THE IMAGE.

The histogram also gives an overall view of the tonal range and "key" of the image. A low-key image has its detail concentrated in the shadows (a high number of data points); a high-key image has detail concentrated in the highlights. An average-key image has detail concentrated in the midtones. An image with a full tonal range has a high number of pixels in all areas of the histogram.

File Formats

RAW Format. RAW is a general term for a variety of proprietary file formats such as Nikon's .NEF, Canon's .CRW and .CR2, and Olympus' .ORF. While there are different encoding strategies, each file ultimately contains the unprocessed image-sensor data. RAW files contain two types of information: the image pixels themselves and the image metadata (data about data), which can include a variety of information about how the image was recorded.

All RAW format image files must be converted by a RAW image converter before they can be utilized. All RAW converters process white balance, colorimetric data (the assigning of red, green, and blue values to each pixel), Gamma correction, noise reduction, antialiasing (to avoid color artifacts), and sharpening. However, the different converters use different algorithms, so the file conversion and optimization is not the same from converter to converter. As a result, the same image may look very different when processed through different RAW converters. Some converters, for instance, will process the tones with less contrast in order to provide editing maneuverability, while others will increase the contrast of the file to achieve a more film-like rendition. Most RAW converters provide a subjective "look," so it is up to individuals to choose a processing engine that suits their taste and workflow.

Although in-camera RAW file processing can optimize image data for sharpness, contrast, brightness, and color balance, among other settings, the current thinking is to minimize these parameters in your in-camera RAW file settings in favor of processing the data using a RAW file converter and the power of a state-of-the-art computer. Using this method, subtle changes to the file can be routinely applied before the data is processed.

Prepping RAW Files for Processing. Only a few years ago, RAW file-processing software was limited to the camera manufacturer's software, which was often slow and difficult to use. With the introduction of software like Adobe Camera RAW and Phase One's Capture One DSLR, RAW file processing has improved drastically and is not nearly as daunting.

The first step is to access the files and save them for editing, storage, and output. You can access your images using a few options, including the software supplied with your camera or photo-editing software that recognizes the RAW file type. Often, image-browsing software is used to initially access the images. Your camera manufacturer may supply this software, or it may be a third-party product.

After displaying and verifying that all of the files exist on the card, save a version of all of your source files prior to making any modifications or adjustments. If you shoot in RAW mode, back up the RAW files as RAW files, as these are the original images (much like original negatives) and contain the most data. Most people use CD-ROMs for this purpose, because the medium is inexpensive and writes quickly from most computers. You can also save your source files to an auxiliary hard drive.

Many wedding photographers, like Californian Chris Becker (known simply as Becker), download their images to a laptop in the field. In Becker's case, he uses a G4 Powerbook and a Lexar FireWire card reader. Once the images are downloaded, he transfers the downloads folder to an iPod (or any portable external FireWire hard drive) for safekeeping.

Get into the habit of creating multiple versions of your work in case you ever need to backtrack to retrieve an earlier version of a file. Once backups are made, you can process the RAW files after certain general parameters are set. You will need to establish things like your default editing program (e.g., Photoshop) and destination folder, file names, numbering sequence, and so forth.

Files can be processed individually or batch-processed. You can apply certain characteristics to the entire batch of images—white balance, brightness, tagged color space, and more. Remember that your original capture data is retained in the source image

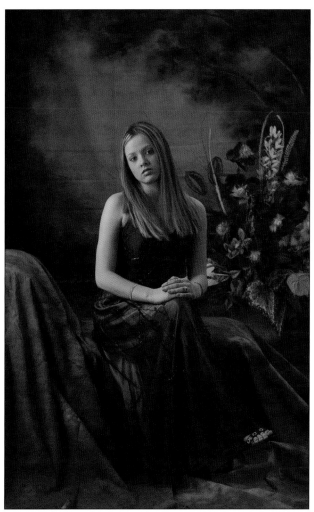 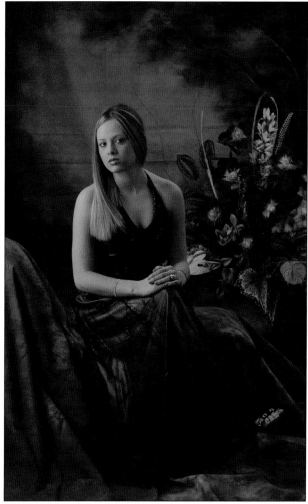

Here is a comparison of JPEG and RAW images processed in Adobe Camera Raw. The RAW file (left) has been changed from Adobe RGB 1998 color space to ProPhoto RGB, the widest gamut color space within Adobe Camera RAW. This increases the amount of color data so that you can carefully edit the color data without a drop-off in quality. Also, in the JPEG file (right), you will notice there is less shadow detail and that the hue of the dress is altered. The color rendition in the RAW file version is much closer to reality. Photographs by Claude Jodoin.

file. Processing the images creates new, completely separate files. You will also have an opportunity to save the file in a variety of file formats, whichever is most convenient to your image-editing workflow.

Adobe Camera RAW. Adobe Camera RAW is Adobe's RAW file converter and it is like a sophisticated application within Photoshop that lets you far exceed the capabilities of what you can do to a JPEG file in the camera. For instance, by changing the color space from Adobe RGB 1998, a wide gamut color space, to ProPhoto RGB, an even wider gamut color space, you can interpolate the color data in the RAW file upward. In the example shown on page 39, the native file size is roughly 2000x3000 pixels. By converting the file to ProPhoto RGB, the file can be easily enlarged to roughly 4000x6000 pixels, the equivalent of a 72MB file when it's opened in Photoshop—and with almost no loss in quality. This is because the ProPhoto RGB color space expands the native color data in the RAW file, making upward interpolation not only possible but practical.

Using the advanced settings in Adobe Camera RAW, you can adjust the image parameters with much more power and discrimination than you can in the camera.

For instance, under the detail menu, you can adjust image sharpness, luminance smoothing, and color noise reduction (luminance smoothing reduces grayscale noise, while color noise reduction reduces chroma noise).

In the adjust menu you can control white balance, exposure, shadow density, brightness, contrast, and color saturation.

The lens menu lets you adjust lens parameters that affect digital cameras, such as chromatic aberration and vignetting. These controls exist to allow you to make up for certain optical deficiencies in lenses but can also be used for creative effects, as well—especially the vignetting control, which either adds or subtracts image density in the corners of the image.

In the calibrate menu, you can adjust the hue and saturation of each channel as well as the shadow tint. (Shadow tint is useful as it provides the basis for color correction of images with people in them. In traditional color printing, color correction is done to neutralize the tint in the shadows of the face and body so they are gray. With shadow tint control, you isolate the shadows from the rest of the image so that you can neutralize them while leaving a warm tone, for example, in the facial highlights.)

In Photoshop CS2, Adobe Camera RAW combines with the modified file browser, called the Bridge, to allow you to group a number of like files and correct them all the same way at the same time. This capability is a modified or selective batch processing that is much more useful than former means of batch processing. Plus you can continue working while the files are being processed.

How JPEG Differs from RAW. When you shoot JPEG-format images, a built-in RAW converter carries out all of the tasks described above to process the image data and then compresses it using JPEG compression. Some camera systems allow you to set parameters for this JPEG conversion—usually a choice of the sRGB or Adobe RGB 1998 color space, a sharpness setting, and a curve or contrast setting.

ADOBE DNG FORMAT

To resolve the disparity between RAW file converters, Adobe Systems introduced an open RAW file format, appropriately named the Digital Negative (DNG) format. Adobe is pushing digital camera manufacturers and imaging-software developers to adopt the new DNG RAW format. Unlike the numerous proprietary RAW formats out there, the DNG format was designed with enough built-in flexibility to incorporate all the image data and metadata that a digital camera might generate. Proprietary RAW file format images that are pulled into Photoshop CS2 can be saved to the new DNG file format with all the RAW file format characteristics being retained. DNG save options include the ability to embed the original RAW file in the DNG file, to convert the image data to an interpolated format, and to vary the compression ratio of the accompanying JPEG preview image.

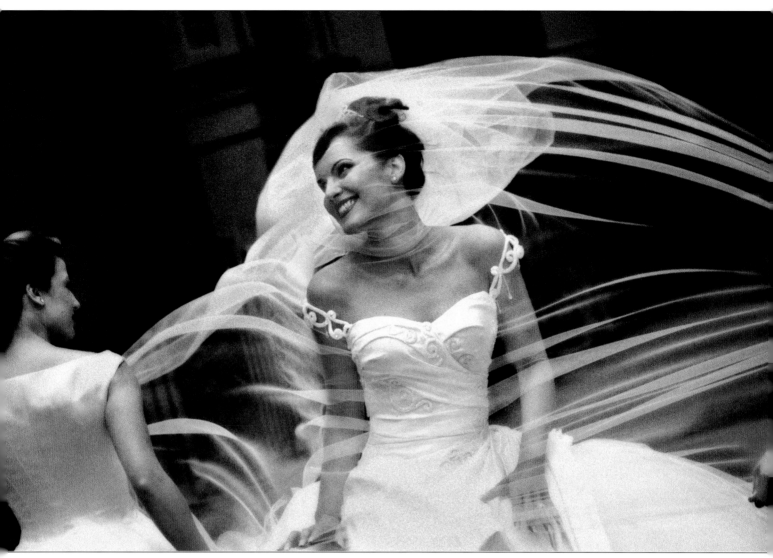

This image, by Yervant, was shot with available light on a windy and overcast day in Melbourne, Australia. The bride's veil was a very light silk and kept flying in the wind while she had fun under it with her bridesmaids. Yervant chooses a few images that he works on in Photoshop, even before showing any proofs to the couple. These are his "signature" images. Yervant copied sections of the image to make a new layer—the veil. Once he had the new layer, he then added motion blur (Filter>Blur) in Photoshop in the direction of the veil's natural flow to heighten the moment. He then selected a section of the background and applied the purple hue to make it less tonally demanding. After he flattened the image, he added a bit of grain (Filter>Texture>Grain) to make the image suit his own personal taste.

JPEGs offer fairly limited editing ability, however, since the mode applies heavy compression to the color data. When you shoot in RAW mode you get unparalleled control; the only in-camera settings that have an effect on the captured pixels are ISO speed, shutter speed, and aperture setting. Everything else is under your control when you convert the file, so you can reinterpret the white balance, the colorimetric rendering, the tonal response, and the detail rendition (sharpening and noise reduction) with complete flexibility. Within limits (which vary from one RAW converter to another), you can even reinterpret the exposure values.

When you use the JPEG format, which is limited to capturing eight bits per channel per pixel, the camera's software essentially throws away a large amount of the captured data. In the typical conversion process, JPEG mode will discard roughly a stop of usable dynamic range, and you have very little control over what gets discarded.

In some ways, shooting JPEGs is like shooting transparency film, while shooting RAW is more like

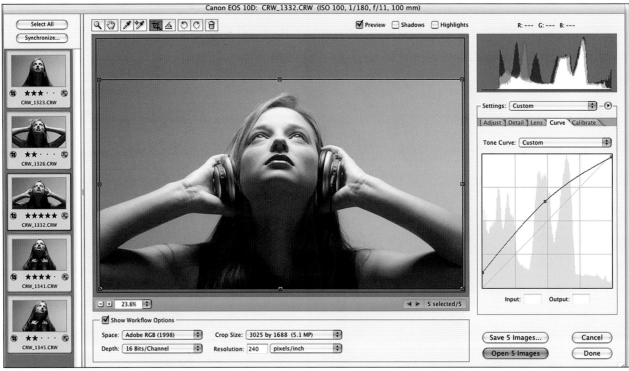

Processing photographs using Adobe Camera RAW in Photoshop CS2 allows great flexibility and speed because you can process multiple images simultaneously. In practice, from Bridge, CS2's powerful browser, open as many RAW files as you choose in Camera RAW, simultaneously. Select the images you want to share settings, adjust the settings, and click Save. That's it, you're done—and while the RAW files are being processed, you can continue to work. Photoshop CS2 also allows you to adjust the RAW file settings before file conversion or pulling the RAW file into the main Photoshop editor, where it can be further optimized and then saved to a wide variety of different file formats.

shooting color negative film. With JPEG, you need to get everything right in the camera, because there's very little you can do to change it later. Shooting RAW mode provides considerable latitude in determining the tonal rendition and also offers much greater freedom in interpreting the color balance and saturation. RAW mode also lets you control detail rendition using noise reduction and sharpening.

There is one drawback to using the RAW format: the file size. RAW files are quite large, so it takes longer to write them to the media. Also, the number of files you can capture on a single CF card or Microdrive is drastically reduced. With the appearance of lower-priced media (at this writing, 1GB cards are retailing for around $79 apiece) cost is becoming less of an issue, but the time it takes to record the information is not necessarily getting much faster. If the kind of shooting you do requires fast burst rates and lots of image files, such as the wedding photographer or photojournalist would experience, then RAW capture may not be your best choice.

If you are locked into shooting JPEGs, shooting in the JPEG Fine mode (sometimes called JPEG Highest Quality mode) will provide the best possible JPEG files. Shooting in this mode creates smaller files, so you can save more images per CF card or storage device. Also, compared to shooting RAW files, JPEGs do not take nearly as long to write to memory. Both factors allow you to work much faster. Shooting in the JPEG Fine mode allows the convenience and speed of the format while maintaining the integrity of the file—although the file quality does not compare to RAW.

The biggest drawback to shooting JPEG files is that they are a "lossy" format, meaning that they are subject to degradation by repeated opening and closing of the file. Most photographers who shoot in JPEG mode either save the file as a JPEG copy each time they work on it or save it to the TIFF format, a "lossless" format that allows images to be saved again and again without degradation. If layers have been added to a file for any reason, the image should be

saved in PSD (Photoshop document) file format, which will preserve the layers. If you do not need to work on the file again, flatten it and save it as a TIFF or JPEG.

Color Space

Many DSLRs allow you to shoot in the Adobe RGB 1998 or sRGB color space. There is considerable confusion over which is the "right" choice, as Adobe

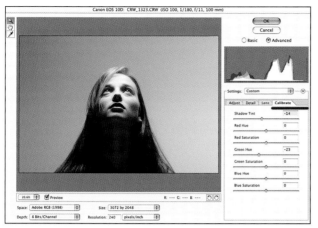

Shadow tint, hue, and saturation were adjusted. Also vignetting was adjusted in the lens menu (not shown).

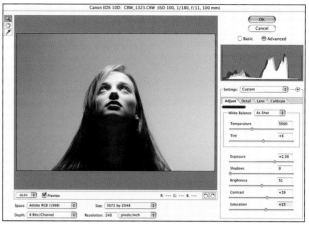

White balance, overall exposure, shadow exposure, brightness, contrast, and saturation were then adjusted.

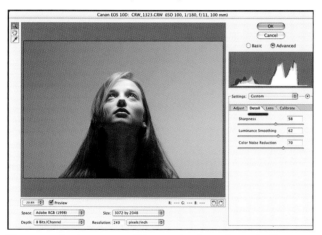

Sharpness, luminance smoothing, and color noise reduction were then adjusted.

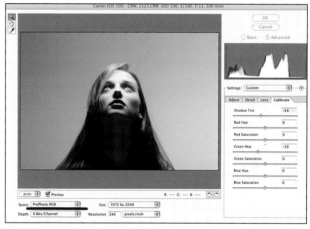

In the image shown here, the file was processed in Adobe Camera RAW. The color space was changed from Adobe RGB 1998 to ProPhoto RGB to increase the amount of color data to be processed.

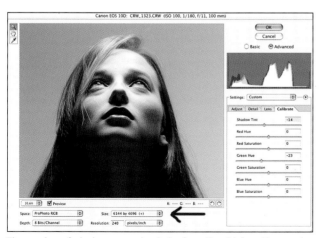

The number of pixels was quadrupled—from the chip's native resolution of 2000x3000 pixels up to roughly 4000x6000 pixels.

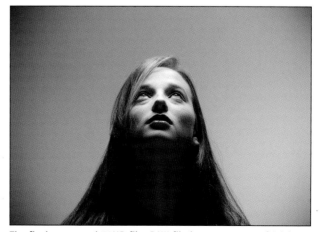

The final, processed 72MB file. RAW file image courtesy of Adobe.

RGB 1998 is a wider gamut color space than sRGB. Photographers reason, "Why shouldn't I include the maximum range of color in the image at capture?" Others feel that sRGB is the color space of inexpensive point-and-shoot digital cameras and not suitable for professional applications. Professional digital-imaging labs, however, use a standardized color space—sRGB—for their digital printers. Therefore, even though the Adobe 1998 RGB color space offers a wider gamut, professional photographers working in Adobe 1998 RGB will be somewhat disheartened when their files are reconfigured and output in the narrower sRGB color space.

Many photographers who work in JPEG format use the Adobe 1998 RGB color space right up to the point that files are sent to a printer or out to the lab for printing. The reasoning is that, since the color gamut is wider with Adobe 1998 RGB, more control is afforded. Claude Jodoin is one such photographer, preferring to get the maximum amount of color information in the original file, then editing the file using the same color space for maximum control of the image subtleties.

Is there ever a need to use other color spaces? Yes. It depends on your workflow. For example, all of the images you see printed in this book have been converted from the sRGB or Adobe 1998 RGB color space to the CMYK color space for photomechanical printing. As a general preference, I prefer images from photographers be in the Adobe 1998 RGB color space as they seem to convert more naturally to CMYK.

Noise

Noise is a condition, not unlike excessive grain, that happens when stray electronic information affects the sensor sites. It is made worse by heat and long exposures. Noise shows up more in dark areas, making low-light photography problematic with digital. It is worth noting, because it is one of the areas where digital capture is quite different from film capture.

Sharpening

In your camera's presets or RAW file-processing software, you will often have a setting for image sharpening. You should choose none or low sharpening. The reason for this is that sharpening can eliminate data in an image and cause minor color shifts. Sharpening is best done after the other post-processing effects are complete.

Metadata

DSLRs give you the option of tagging your digital image files with data, which typically includes date, time, caption, and camera settings. Many photographers don't even know where to find this information, but it's simple: in Photoshop, go to File>File Info and you will see a range of data including caption and identification information. If you then go to EXIF data in the pull-down menu, you will see all of the data that the camera automatically tags with the file. Depending on the camera model, various other information can be written to the EXIF file, which can be useful for either the client or lab. You can also add your copyright symbol (©) and notice either from within Photoshop or from your camera's meta-

REFORMAT YOUR CARDS

After you back up your source files, it's a good idea to erase all of the images from your CF cards and then reformat them. It simply isn't enough to delete the images, because extraneous data may remain on the card and cause data interference. After reformatting, you're ready to use the CF card again.

Never format your cards prior to backing up your files to at least two sources. Some photographers shoot an entire job on a series of cards and take them back to the studio prior to performing any backup. Others refuse to fill an entire card at any time, opting to download, back up, and reformat cards during a shoot. This is a question of preference and security. Many photographers who work with a team of shooters train their assistants to perform these operations to guarantee the images are safe and in hand before anyone leaves the event.

data setup files. Adobe Photoshop supports the information standard developed by the Newspaper Association of America (NAA) and the International Press Telecommunications Council (IPTC) to identify transmitted text and images. This standard includes entries for captions, keywords, categories, credits, and origins from Photoshop.

Here's a tip: If you perform complex manipulations to an image in Photoshop, the only way to preserve the history of operations is to save the file as a PSD (Photoshop document). Then, under "history" in File>Info you will see every operation performed to the file.

◘ Printing Options

Many photographers have the equipment and staff to print their own images in house. It gives them a level of control over the process that even the best labs cannot provide.

Other photographers have devised interesting ways to save money by employing the lab's wide-format digital printers. David Williams, for example, uses a lab called The Edge in Melbourne, Australia. The Edge uses a Durst Lamda Digital Laser Imager, which produces full continuous-tone images straight from Macintosh or PC files on photographic media. Williams prepares Photoshop files of finished album pages, panoramas, small prints, and proofs on a 32-inch wide file (the width of the lab's Lamda), utilizing every square inch of space. The 32x32-, 32x50-, or 32x70-inch files are all output at one time—and very inexpensively. The lab even trims all of the images for Williams, thus increasing his productivity and lowering his costs.

David Williams assembles his images in single files to take advantage of the Durst Lamda's 32-inch-wide printing capacity. This file is 32x50 inches. The lab even trims all his images.

Williams follows the guidelines of the lab and works in Adobe RGB (1998) color space at the gamma recommended for either PCs or Macs. The files may be TIFFS or JPEGs at 200 or 400dpi. The Edge will even provide a calibration kit on request to better coordinate your color space to that of the lab's.

GLENN HONIBALL: MASTER PHOTOSHOP RETOUCHER

Glenn Honiball is the ultimate Photoshop practitioner. His clients are ad agencies—the most *prestigious* agencies—from around the world. He has worked for the likes of J. Walter Thompson, Optic Nerve, Brainstorm, Saatchi & Saatchi, and Zig, to name a few. The companies he's worked for also read like a who's-who list—Ford, GE, BMW, Coke, Sony, Kraft Foods, and the NFL, for example. His assignments are specific ("Change this model 2003 Pontiac into the model 2004 Pontiac"), but it's no problem for Honiball, who is used to making visual magic happen for advertisers.

Today, Honiball relies almost exclusively on Photoshop, but it wasn't always that way. "When I started my career, I was using a Hell Chromacom system (similar to a Scitex system). It could do page assembly, color correction, and retouching—however, with no undos and no layers! All commands were in German and all were string-based commands, not icons! The system cost about one million dollars, and retouching was charged out at about $650 per hour. I worked on that system for about nine years. Photoshop wasn't around, and the Macs weren't capable of much at that time."

There were two images supplied of this truck on two different backgrounds. The two images had to be merged to create a single image. Many details of each truck did not line up and had to be aligned and integrated together to appear as one image. The clone tool was used extensively throughout this image.

Using only one image from the client, the back of this KIA van was redrawn to replace items removed from the original image. This was accomplished using the clone tool. Small details were not overlooked, like eliminating the original reflection of the people in the rear-view mirror. Some areas were worked with the brush tool to create shapes that were not there. Noise was added to reduce the smoothness of the brushed areas. The exterior color of the van was also color-corrected using curves and a mask.

In Photoshop, there are many ways to achieve the same the work, so retouchers cannot get away with mediocre

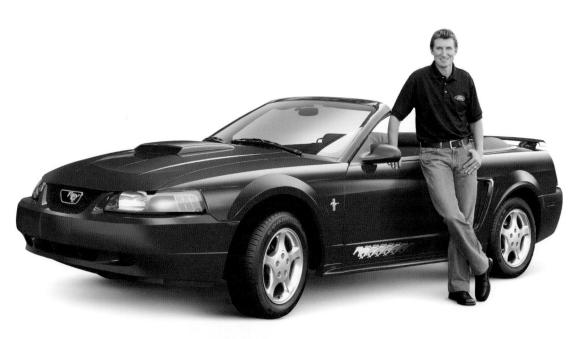

The car was cropped out of the existing city background using the pen tool. Many reflections were deleted from the car using a clone brush set to a very low opacity. The brush was "massaged" all over the car to eliminate reflections. Because Honiball likes to use a large brush when eliminating reflections, one area (say, a quarter panel) would sometimes be masked off to restrict the cloning effect. Using the pen tool, shapes were created in some areas of the car, and some hard edges were put back onto the car using the brush tool with a low opacity and gradually built up to look realistic in order to create the look of a shiny paint job. The car was to look like it had been shot in a studio. The subject, Wayne, was added, and reflections and shadows were applied to make the effect more realistic. Shadows were added on a separate layer and were created by using the brush tool at a low opacity and a brush shape that would reflect the angle the car is on.

This toaster had many of the reflections taken out, and most of the image was "repainted." This was accomplished by taking constant color readings of the original toaster and painting with this color over the reflections. A small amount of noise was also added to the smooth brushed surfaces. The smudge tool was also used to perfect some of the lines. Masks were made of the toaster surface elements, and small amounts of highlighting were added with the brush tool to define shape. The logos were supplied as flat Illustrator files that had to be curved, colored, and contoured to look natural on the toaster surface. The toast was a second shot that was added to the toaster.

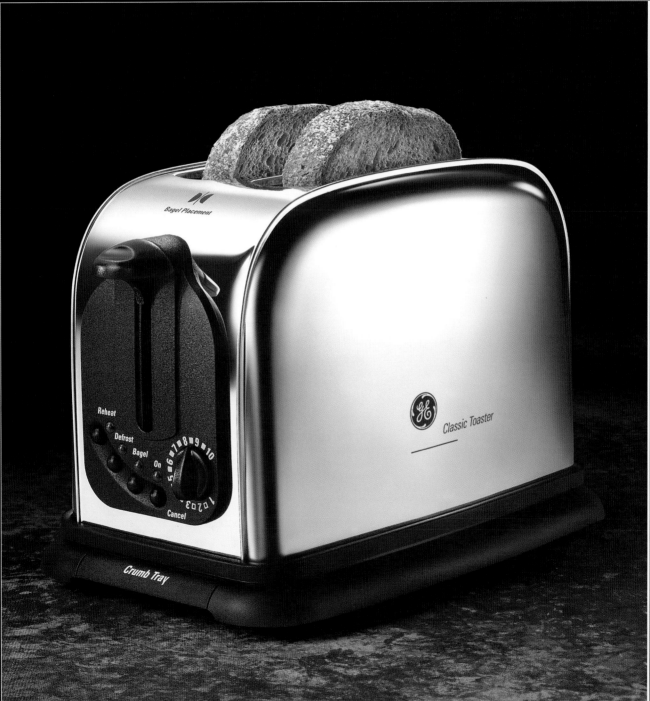

A new front end was added to this van because it changed for this model year. All that was supplied was the front grill and bumper. The new front end was lightly shaped with the liquify filter and color corrected to match the existing van's color. Using a combination of the clone tool and the eraser tool, the new front end was merged with the older van.

The color of the car was changed to a two-tone blue and it was placed on a supplied snow scene. The color was changed using the channel mixer and had to be built up to some degree because of the light hue of the original car color. Shadows and reflections were added by multiplying the shapes onto the car, then distorting them so that it wasn't obvious where they came from. The see-through windows were created with the brush tool on a separate layer by drawing the necessary shapes with the pen tool then brushing in white until the desired effect was achieved. The license plate was removed with the clone tool, and the wheels were replaced with those from a supplied second shot. The wheels had to be distorted slightly with the transform function to fit properly.

— THREE —
COLOR MANAGEMENT AND DEVICE PROFILING

Whether you are doing your own printing in-house or are working with a lab, you need an efficient and precise system of color management. This guarantees that what you see on your in-studio monitors will be matched as closely as possible in color and density to the final output.

Jeff Smith, an award-winning photographer and author, is like most photographers who have made the transition from film to digital. His workflow model with labs was well established, and he was happy with years of beautiful printing from negatives. Smith's studio simply cut the negatives, marked the order, and sent it off to the lab, and the next time they saw the order, it was beautifully finished and ready to package and deliver. If the order wasn't right, the lab would redo it.

Between Two Walls was taken in San Miguel De Allende, Mexico, by wedding photographer Joe Buissink. He had just finished making an image of the couple for Grace Ormode's *Wedding Style* magazine, and as he was climbing the stairs to leave, something compelled him to look over his shoulder at the couple as they descended the stairs. What he saw was this image of the bride between the walls. The image was made with a Nikon D2H and 17–35mm f/2.8D ED-IF AF-S Zoom-Nikkor at the 22mm setting. The only Photoshop effect used was an edge treatment. Buissink, a film shooter by preference until recently, is just beginning to appreciate digital capture and post-production in Photoshop.

Jeff Smith has earned a great reputation by photographing seniors the way they like to be photographed. Further, he controls the output of his prints and the rendition of his files in Photoshop. He doesn't overdo it; he uses a makeup artist on location or in studio and then uses minimal retouching and diffusion in Photoshop.

RICH NORTNIK, JR.: ILLUSTRATOR EXTRAORDINAIRE

Educated in fine arts, Rich Nortnik, Jr. is considered to be one of the world's foremost Photoshop experts. In the last five years, he has been awarded numerous design and digital illustration awards and has even been christened an official "Photoshop Guru."

As senior designer/illustrator for the Shaw Group, one of the world's largest engineering and construction firms, he has designed artwork and illustrations for transportation projects all over the world.

Nortnik's first exposure to Photoshop and digital illustration was when he saw a young artist using the airbrush tool in Photoshop 2.0 to color his line drawings. Says Nortnik, "From that point on I was Adobe crazy—I ate, slept, and drank Photoshop."

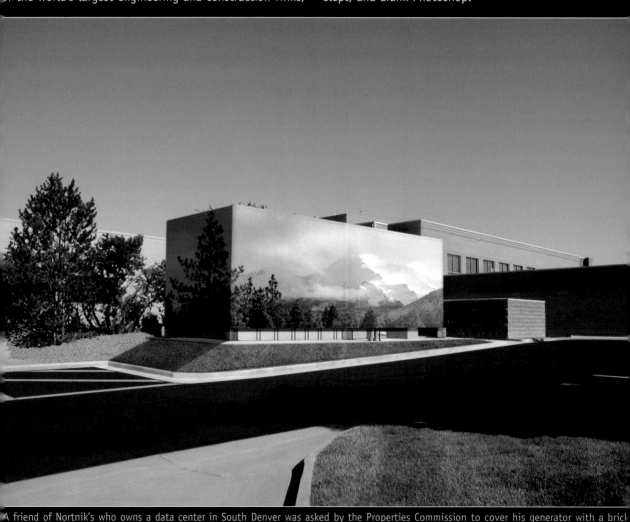

A friend of Nortnik's who owns a data center in South Denver was asked by the Properties Commission to cover his generator with a brick wall. Nortnik's friend thought the wall would look unattractive and be very expensive to build. The pair got together and came up with the idea of covering the generator with a mountain scene on canvas—something often done in New York City when making changes to high-rise buildings. The wide-format inkjet-printed material is held up by a pulley system and has a life span of three years or more. Nortnik's job was to show what the project would look like when complete. The first thing he did was clean up the existing back of the building in Photoshop, giving it a clean, professional look. He then painted in the two mountain scenes over the generator to achieve the real "after" look.

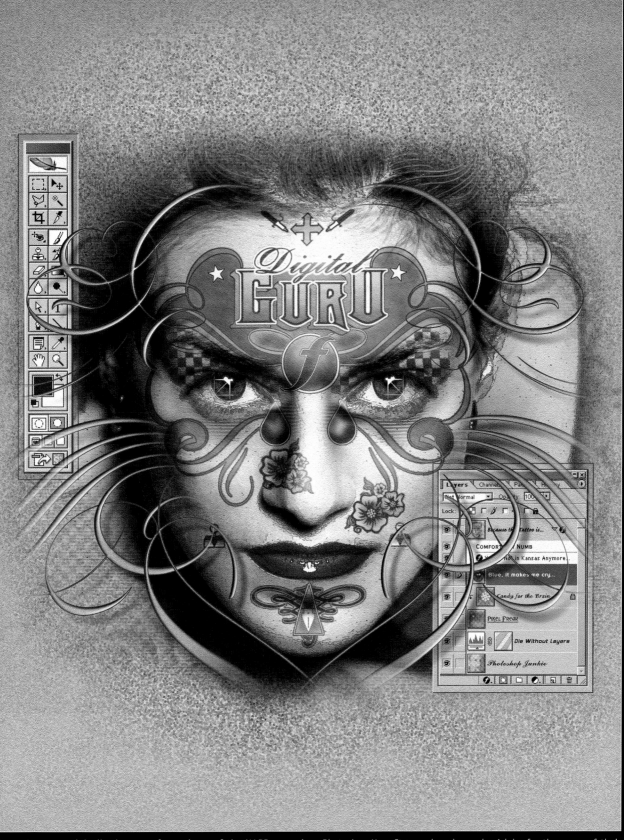

Tattoo You was originally the cover for an issue of the NAPP magazine, *Photoshop User*. It was also chosen by Adobe for the cover of their Photoshop 7.0 press kit. This was a fun and challenging piece, according to Nortnik. "Most of the time," he says, "I look back at something I'm very proud of and really forget how I got there." While he can't remember precisely how he built this image, Nortnik recalls that he used five different image files and over three hundred layers. The reason for so many files and layers is because he likes to experiment with different layer modes and effects when building a complex piece.

LEFT—*Welcome to the Machine* is a tribute to the Pink Floyd song bearing the same name. This piece also had over two hundred layers and several image files that were merged at the end. "If you are a Pink Floyd fan," he says, "listen to the song and you will find clues to the artwork in this piece."

FACING PAGE, TOP—*End Terrorism* is a version of a personal piece Nortnik designed for his company, the Shaw Group, as a cover for a Department of Defense RFP (request for proposal). It is full of many, many details of 9/11.

FACING PAGE, BOTTOM LEFT—*Dead or Alive* is a movie-poster graphic in the tradition of Drew Struzan, with political characters from current events. (*Note:* Drew Struzan is a well-known designer of movie posters, having produced award-winning posters for classics like *Blade runner,* the Harry Potter movies, and *Indiana Jones and the Temple of Doom.*) Nortnik began this poster at the start of the war in Iraq. Most of the poster was done by hand, using Photoshop's airbrush tools and many paths. He wanted the piece to have an "Indiana Jones" feel to it. *Photoshop User* magazine published this piece, and Nortnik was nervous about the response he would get. To his surprise, the response was overwhelmingly positive.

FACING PAGE, BOTTOM RIGHT—*Litigation* is an illustration done for *Rangefinder* magazine that expresses the anguish people go through when involved in the litigation process. Many layers and files were combined to produce the finished piece.

Nortnik's work is clearly influenced by Salvador Dali, an artist whom he admires and has studied. While the work created for various construction and engineering projects pays the bills, Nortnik's personal images are truly works of art and usually reflect something he feels very strongly about. For example, the image titled *Welcome to the Machine* bears the same name as a Pink Floyd song. Nortnik, a huge fan of the group, created this as his personal tribute to the band. Other personal work, like *Tattoo You,* was destined for the cover of the National Association of Photoshop Professionals (NAPP) magazine—but when Adobe saw it, they liked it so much they decided to use it as the cover for the Adobe Photoshop 7.0 press kit.

Nortnik also uses and is an expert at Adobe Illustrator and Corel Painter. He also loves the Andromeda and Kai (KPT) plug-ins and uses many different tools when designing a complex piece. One of his personal pieces, *End Terrorism,* uses an eagle and the United States Senate building with an antenna on top that appears to have a light beam emanating from it. The work was originally used as the cover for a proposal to the Homeland Security Department.

To see more of his work, visit Rich Nortnik, Jr.'s website: www.richnortnikjr.com.

انهاء الإرهاب

ALERT IS HIGH

SADDAM HUSSEIN

AND HIS

LAST CRUSADE

Have The Adventure Of Your Life Keeping Up With The Husseins

Coming To Your Television Set LIVE From Baghdad, March 21, 2003

When his lab switched over to digital, however, he found he was not getting the quality he had gotten for the last 15 years. "Purple skin wasn't the look we were going for," he said. With digital, Smith and company had to take over doing all the color- and tonal-correction work and were charged the same price for digital output as printing from negatives. This meant that the studio's lab bill stayed the same, but he had to employ additional people to get all the files ready for the lab.

Smith investigated inkjet and dye-sublimation printers and found either the quality, cost, or time to produce prints wasn't to his liking. He started to fantasize about the Fuji Frontier—the Rolls Royce of digital printers. Smith found, instead, an all-in-one digital printer/paper processor called the NetPrinter from Gretag. The Netprinter, as well as other similar digital printers from other manufacturers, are self-contained printers/processors that print on almost any photographic paper. Smith's Netprinter outputs up to 12x18-inch prints at 500dpi for an average cost per 8x10 of 35 to 45 cents—and the machine can print up to two hundred prints per hour!

So what does this story have to do with color management? Well, what Smith found out was that even though the Netprinter came loaded with ICC profiles, the studio was not getting consistent results. In the end, what Smith ended up doing was purchasing EyeOne Calibration software to calibrate each monitor and write specific ICC profiles for the machine. This got the monitors close to the final output on paper, but still the staff, as a group, had to learn to interpret the subtle differences between the

FACING PAGE—Kersti Malvre is as much an artist as a photographer. She has studied both disciplines and excelled at both. Her current imagery incorporates both art forms, as she often performs her retouching and creative enhancements on a digital file, then sends it off to her printer, who outputs a medium-format black & white negative. "Then it is printed on fiber-based paper that I can paint," she says. In this image, the Photoshop work was extensive. First, she neutralized the whites in the image, then applied Gaussian blur in a new layer. She adjusted the image in curves and applied numerous brush strokes with varying opacities. She added strokes to the image's various layers and applied a series of vignettes, with red on top.

colors and contrast of the monitors and how they reproduced on specific papers.

A year later, Smith's staff was trained to interpret color, the customers were happy, and he was happy, too. According to Smith, "For our studio, this was a necessary step to make digital as profitable as shooting with film."

▣ It's an RGB World Now

By mixing red, green, and blue (RGB) light in varying proportions and intensities, a large percentage of the visible spectrum can be represented. RGB devices (including most digital cameras, scanners, and monitors) use red, green, and blue light—or channels—to reproduce color. A computer monitor, for example, creates color by emitting light through red, green, and blue glowing phosphors that react with thousands or millions of picture elements (pixels) located on the glass surface of the monitor to produce color.

EVEN TWO DEVICES OF THE SAME MAKE AND MODEL WILL DISPLAY DIFFERENCES BASED ON MINUTE VARIATIONS.

While this sounds like a simple concept, it can become quite complicated when multiple devices (say, a camera and a monitor and a printer) are involved. This is because no two devices produce or interpret colors in exactly the same way. Even two devices of the same make and model will display differences based on minute variations in manufacturing, the age of the device, and other factors.

Color management, then, is the process used to minimze these discrepancies, controlling the color from input, to display, to output—producing predictable and repeatable results. To achieve this, the color management system performs two important functions: (1) it interprets the color values embedded in an image file and (2) maintains the appearance of those colors from one device to another.

So why, even in a color-managed system, does the print sometimes look different than the screen

image? The answer lies not so much in the color-management process, but in the differences between media. Because monitors and printers have a different color gamut (fixed range of color values), the physical properties of these two different devices make it impossible to show exactly the same colors on your screen and on paper. However, effective color management allows you to align the output from all of your devices to simulate how the color values of your image will be reproduced in a print. As Jeff Smith found out, there is still a learning curve on the human side in determining and correcting these subtle differences.

◼ Monitor Profiles

As noted, if you set up three identical monitors and had each display the exact same image, the images would all look a little bit different. This is where profiles come into play. Profiling, which uses a hardware calibration device and accompanying software, characterizes the monitor's output so that it displays a neutral or at least a predictable range of colors.

THE PROFILE WILL SEND A CORRECTION TO THE COMPUTER'S VIDEO CARD, CORRECTING THE EXCESS GREEN, MAGENTA, AND BRIGHTNESS.

A monitor profile is like a color-correction filter. Going back to the example of the three monitors above, one monitor might be slightly green, one magenta, and one slightly darker than the other two. Once the monitor is calibrated and profiled, and the resulting profile is stored in your computer, however, the profile will send a correction to the computer's video card, correcting the excess green, magenta, and brightness, respectively, so that all three monitors represent the same image identically.

Monitor profiling devices range from relatively inexpensive ($250–$500) to outlandishly expensive (several thousand dollars), but it is an investment you cannot avoid if you are going to get predictable results from your digital systems.

It is recommended that you set your computer desktop to a neutral gray for the purpose of viewing and optimizing images. Because you will most likely make adjustments to color and luminosity, it is important to provide a completely neutral, colorless backdrop to avoid distractions that might affect your critical ability to judge color.

To optimize your working area the room lighting should also be adjusted to avoid any harsh direct lighting on the face of the monitor. This will allow more accurate adjustments to your images and will reduce eyestrain. Attempt to keep ambient light in the room as low as possible.

◼ Gamma

Gamma refers to the monitor's brightness and contrast and represents a known aim point. For example, if your video card sends your monitor a message that a certain pixel should have an intensity equal to x, the monitor will actually display a pixel that has an intensity equal to x. Typically, monitors used with Macs have a default gamma setting of 1.8, while monitors used with PCs and Windows have a default setting of 2.2. Both operating systems allow gamma to be adjusted, which can be important if your lab is using a different gamma than you. Also, both systems have built-in self-correction software to optimize the accurate appearance of images. (*Note:* Monitor gamma is not to be confused with the film exposure/development system similar to Ansel Adams' Zone System.)

◼ Camera Profiles

DSLRs are used in a wide variety of shooting conditions. This is especially true in wedding photography, where the photographer may encounter a dozen different combinations of lighting in a single afternoon, all with varying intensities and color temperatures. The wedding photographer is looking at a world of color.

Just as all monitors are different, all digital cameras vary at least a little in how they capture color. As a result, some camera manufacturers, like Canon, don't provide device profiles for their cameras.

Marcus Bell is known across two continents as a master photographer. In his native home of Australia, he has been awarded Landscape Photographer of the Year, Wedding Photographer of the Year, and Portrait Photographer of the Year—an unprecedented accomplishment.

His image called *Workers,* taken in Greece many years ago, has been given new life in his Photoshop darkroom. The original image was captured on infrared film, but as he developed an understanding of color and Photoshop skills, he realized he had a wealth of existing material to work with in completely new ways.

Bell's first step when working with a digitized film image is to clean up the photograph—removing any dust and scratches. He works in steps and saves versions of his progress so that if he is unhappy with any outcome, he doesn't have to start over at the beginning.

The next step is to bring the image to life in terms of tone and contrast. When working with a negative in the

darkroom, a printer will dodge and burn select areas. Marcus does exactly the same using Photoshop. He believes that a good understanding of traditional dark room techniques and skills is valuable in the digital dark room.

Bell likes to make selections, then uses the levels to control how light or dark the area is. Selections are often feathered, sometimes as much as 150 pixels, so the transition areas are invisible to the eye. All levels and contras

After working the black & white image to a point where he's satisfied with it, Bell embarks on colorizing it in Photoshop. This image is called *Lockout,* and it is one of his favorites.

From original scan through many generations, Marcus Bell colorized the image he calls *Workers* until it took on a completely new life.

adjustments are carried out on the original 16-bit scan, then converted to 8-bit for further work.

By selectively darkening and lightening certain areas, you can add shape to the photograph and make it more dimensional. You're also able to maintain detail in the shadow areas, emphasize the center of interest, and create leading lines. This allows you to take images a step further. The advantage Photoshop has over a traditional darkroom is that it's so easy to apply numerous different paper contrast grades in a single print. Bell might adjust one selection to lower the contrast, while he might increase contrast in another selection. The effect is like using different contrast grades in a single image.

Bell makes a copy of the background layer and then works on the copy, leaving the original untouched underneath. This way he can always revert to the original image. Once he's made adjustments in the selection, the surrounding unchanged areas are deleted so just the adjustment sits on top of the base image. The process is repeated for each area, so in the end he might have five or more layers, each representing a lightening, darkening, or change in contrast to a particular area. When the process is finished, he can save this file, open a new version of the file, and flatten the layers before continuing.

At this stage, he has a good-quality black & white image. He reasons that if he can't get the image to flow in monochrome, he has little chance of making it work in color. On the other hand, a photo that works well in black & white can be even better with the use of the right colors. "I've learned a lot about the use of color by studying artists, especially Jeffrey Smart [a widely exhibited Australian artist now living in Italy]," Bell says. "These artists use color as a compositional element, and with Photoshop, photographers can do the same."

Bell claims the role of an artist, starting with a blank canvas and adding color according to the message or emotion he wishes to convey. This is why he likes starting with a black & white image, selectively adding his own colors without being influenced by what was already there.

Bell doesn't use color for the sake of creating a pretty picture, but rather to emphasize different aspects within the image. "By choosing colors that complement or oppose each other," he says, "you can take control of your image, guiding the eye as you please and adding weight to certain elements over others."

After converting the grayscale image to the RGB mode, he selects the areas he wants to work in using the lasso tool and then opens up the color balance dialog box to produce the desired color. By using layers for each area, he can always return to adjust the color, without affecting everything else in the image.

Bell sometimes needs to do a little dodging and burning after adding color, or the result will look a bit flat. His selections are feathered—2 to 10 pixels—so the colors blend together naturally. Bell also uses the opacity control on each layer to change the weight, so his choice of color can be subtle or strong. Another technique he likes is using the brush tool in color mode.

Marcus is amazed how this approach has changed his work. "I find I'm looking at my work in a totally new light," he says. "Images I might have passed over before now have me thinking, 'Wow!'"

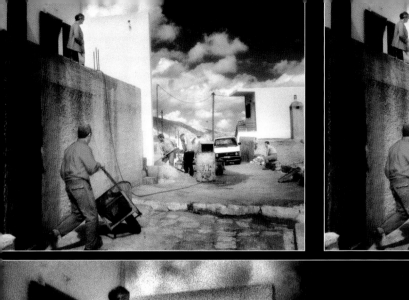
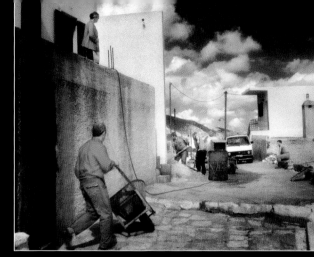
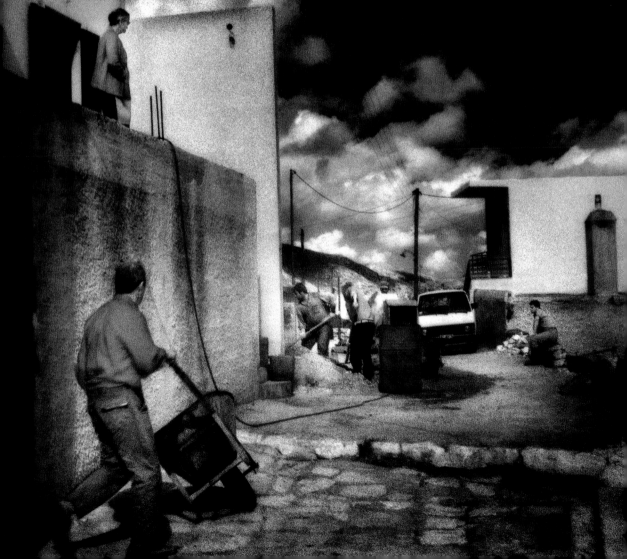

i1 RGB Target 1.5

LEFT—Printer profiles are built by printing a set of known color patches. A spectrophotometer then reads the color patches so the software can interpret the difference between the original file and the printed patches. This is a target that Claude Jodoin uses. **FACING PAGE**—Kersti Malvre is highly proficient in Photoshop. Much of the work she does to a file uses Photoshop's brushes and various blending modes, incorporating a multitude of layers.

After all, if the manufacturer made one profile for all their cameras, it would prove somewhat useless. Additionally, there are software controls built into the setup and processing modes for each DSLR that allow photographers sufficient control to alter and correct the color of the captured image.

Creating these custom camera profiles is beneficial if your camera consistently delivers off-color images under a variety of lighting conditions, captures skin tones improperly, or fails to record colors accurately when such precision is critical, such as in the fashion and garment industry. Commercial photographers, for example, often use camera profiles to satisfy the color rendering needs of specific assignments.

One of the most inexpensive and effective camera profiling systems is the ColorEyes profiling setup. It is simple enough, albeit time consuming. Basically, you photograph a Macbeth ColorChecker (a highly accurate and standardized color chart) and create a profile using ColorEyes software. The software looks at each patch and measures the color the camera saw. Next, the software calculates the difference between what the camera saw and what the reference file says the color is supposed to be. Third, the software builds the profile, which is actually a set of corrections to make the camera "see" more accurately.

While the wedding photographer would not necessarily profile each camera used on each location, a camera profile might prove beneficial in a studio setting where a specific set of strobes produces consistently off-color results. That profile would not be useful for any other situation than that studio and those lights, but it is more convenient than other means of color correction.

Fortunately, most digital cameras are manufactured so that their color gamut is very close to a universal color space, such as sRGB or Adobe RGB 1998. Color space is a type of universal profile. Anytime a file is sent from one person to another (or from you to your lab), it should be in one of these universal color spaces. (*Note:* Most labs have a preferred color space. Usually this is sRGB, but not always. Check with your lab to make sure your files are using the correct color space.)

◪ Printer Profiles

Printer profiles are built by printing a set of known color patches from a special digital image file. A spectrophotometer is then used to read the color patches so the software can interpret the difference between the original file and the actual printed patches. This information is stored in the form of a printer profile, which is then applied to future prints to ensure they are rendered correctly. Custom printer profiles ensure that you are getting the full range of colors that your printer can produce. For best

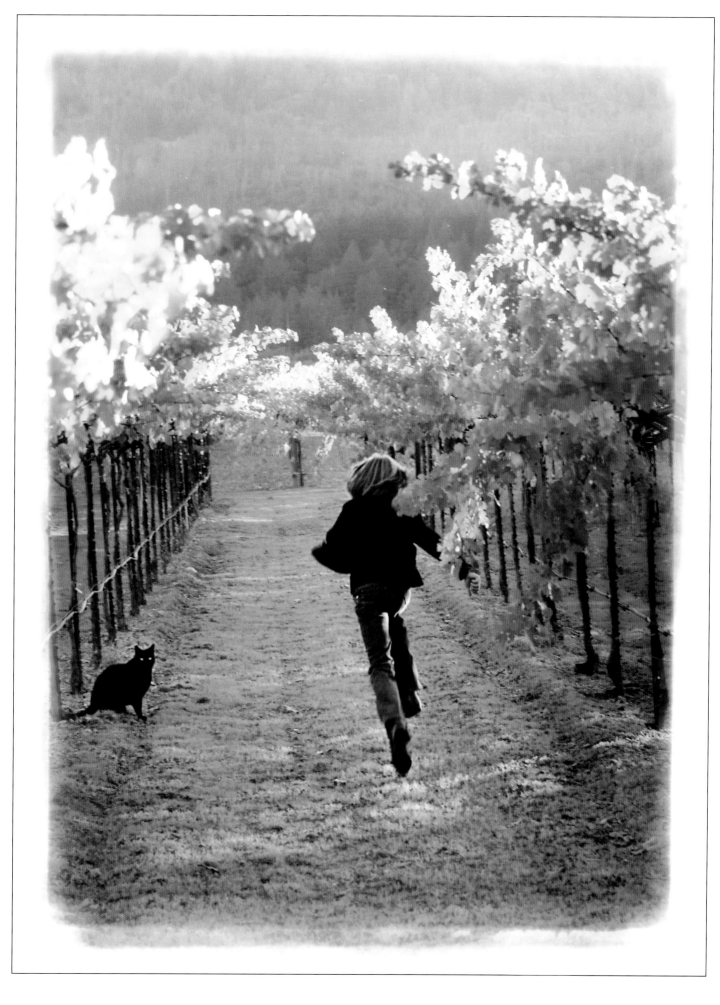

results, use a unique custom profile for each inkjet paper you use.

Custom profiles, such as the Atkinson profiles, which are highly regarded, can be downloaded from the Epson website (www.epson.com) and a variety of other sites. Here's how it works: go to the website, then download and print out a color chart. Mail it back to the company, and they will send you a profile or set of profiles via e-mail.

Another great source of custom profiles for a wide variety of papers and printers is Dry Creek Photo (www.drycreekphoto.com/custom/custompro-files.htm). This company offers a profile-update package so that each time you change ink or ribbons (as in dye-sublimation printing) you can update the profile. Profiles are available for inkjets, dye-sub printers, and small event printers (Sony); Kodak 8500- and 8600-series printers, Fuji Pictography, RA-4 printers (LightJet, Durst Lambda/Epsilon, Fuji Frontier, Noritsu QSS, Gretag Sienna, Kodak LED, Agfa D-Lab, etc.); Color Laserjets and Thermal printers. (*Note:* Most of the expensive commercial printers that labs use include rigorous self-calibration routines, which means that a single profile will last until major maintenance is done or until the machine settings are changed.)

▪ Soft Proofing

Output profiles define your printed output, as well as your ability to "soft proof" an image intended for a specific printer. A soft proof allows you to see on the calibrated monitor how an image file will appear when printed to a specific profiled output device. By referring to an output profile in an application like Photoshop, you can view out-of-gamut colors on your display prior to printing. Needless to say, accurate output profiles can save time, materials, and aggravation.

GIGI CLARK: HANGING OUT AT THE PHOTOSHOP CAFE

With four college degrees, Gigi Clark has a varied background including multimedia, instructional design, graphic design, and conceptual art. She brings all of her talents to her photography business in Southern California. She has received numerous awards and honors, including several First Places in both PPA and WPPI competitions, as well as the first-time offered Fujifilm Award for Setting New Trends. Hearing-impaired since birth, Gigi says that this "ability" has increased her sensitivity to the potential of art to stimulate the senses. She comments, "I do not break the rules for the arts until I have learned them well. In my photography, I have broken many rules of our craft. I have been a photographer most of my life—incidentally, long before I became an installation artist. In a sense, I have come full circle, embracing all that I know and implementing it in my work."

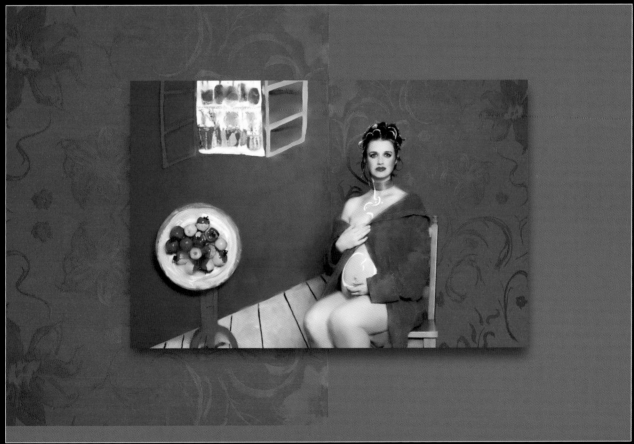

This Gigi Clark image was inspired by an ad from a European fashion magazine, an ad inspired by the colorful paintings of Henri Matisse. This photograph is based on his *Harmony in Red*. Drawing additional inspiration from her appreciation for the beauty of pregnant women, whose swollen bellies embody the creative process as a whole, Clark calls this image *The Art of Creation*. To create the image, four large canvases were clamped together, giving an 8x8-foot area that Clark painted in the style of Matisse. The model's hair, neck, and belly were also decorated, essentially painting her into the painting. She was then photographed in front of the canvases. In Photoshop, the seams were removed, and a tad of color correction was done. The model was then worked with the smudge tool to enhance the painterly qualities. The resulting photograph floats on an inverted sample of the background. This image has won numerous awards, including inclusion in the PPA Loan Collection. It is also part of the ASP Traveling 100 Collection and hangs at the International Photography Hall of Fame.

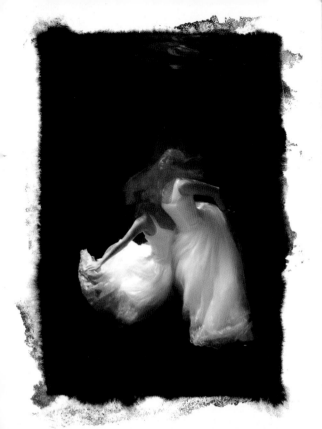

Clark was inspired by Howard Schatz's book *Waterdance*, a collection of underwater photographs he took of the San Francisco Ballet. Her take would be to apply the same technique to brides so they would look like angels that fell from heaven but didn't fall from grace. This image was shot of two girls who asked Gigi to photograph them underwater together as they were best friends for many years. To add a mysterious allure to their pose, she gave them a piece of red chiffon, and asked them, while underwater, to move against the fabric. The resulting image was taken using a Nikonos V camera with Fujifilm Press 800 film. In Photoshop, the image was corrected for contrast, and minimal retouching of air bubbles. As a final touch, Clark placed an inkblot border that she had scanned from a postcard.

The idea for this photograph was to show the special qualities of the bride's very emotional purchase—her wedding dress. The bride kept referring to this expensive, designer dress as her "Titanic" dress, which inspired the eventual artwork. Unbeknownst to the bride, her maid of honor and Clark conspired with the salon to photograph the dress on a mannequin. Clark asked herself, "What if the image was aged before its time, and looked like an artifact found on the ship, something left behind after a truly memorable event?" She printed the image onto black & white paper, then toned it with Halochrome to produce a Daguerreotype look. She then sandwiched the image between two pieces of ragboard. Next, she found nuts and bolts, spray-painted them in gold, and literally riveted them through the boards, in a pattern reminiscent of the sides of a cruise ship of the period (1912). She then framed the artwork under glass, and as luck would have it, the glass cracked. Rather than call this artwork a loss, she took another image, this time documenting the cracked glass ensemble with the dress photo enclosed. In Photoshop, she used the colorization and burn tools to create an aged, water-stained appearance. Now, it looks as if someone dragged it up from the sea, giving it a true museum-like appearance.

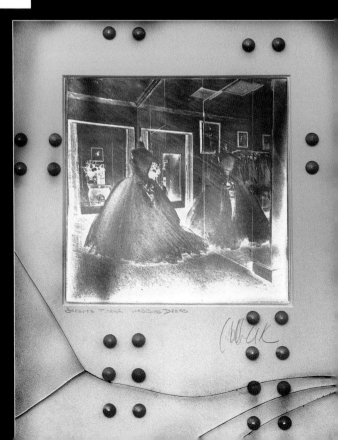

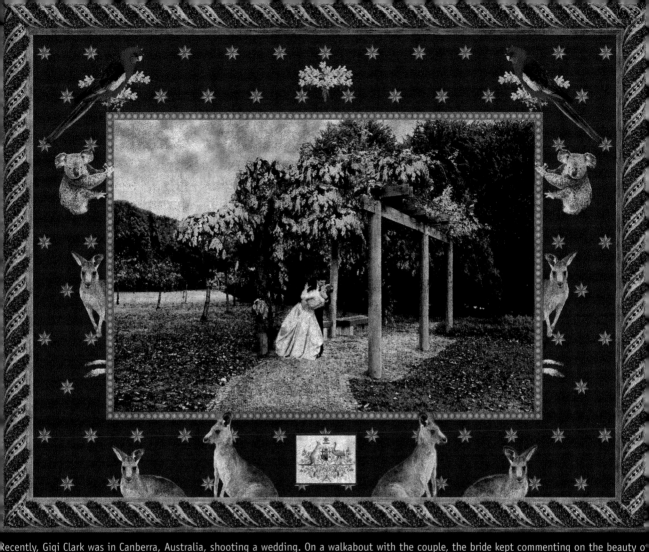

Recently, Gigi Clark was in Canberra, Australia, shooting a wedding. On a walkabout with the couple, the bride kept commenting on the beauty of the city of her youth. Clark thought the fall colors reflected the color scheme usually found in medieval tapestries created to commemorate a special occasion. Historically, these tapestries reveal the details of the event along with the creatures found nearby. Clark spent the better part of the two weeks in Australia, documenting native animals such as the kangaroos and koalas, and kept on the lookout for "special events," such as the crimson rosellas, birds that mate for life, that showed up every time the couple appeared.

Next, Clark scanned a kitchen towel that had a weave much like that of the tapestries, and did a bit of "stitching" in Photoshop to create a larger area. For the outer border, she used the sculpted white marble columns from the Duomo in Florence, Italy, and filled the empty space between them with red Japanese maple leaves that she had photographed in Canberra, near the bridal site.

In the centerpiece image, the bride's dress was reworked using adjustment layers to enhance folds in the fabric. The entire scene was also manipulated lightly using Photoshop filters (fresco, poster edges, and rough pastels) to give the subjects definition. A displacement map was then applied to the couple, which creates woven-looking edges. A blue sky with clouds was also added.

The inner frame was created using the spherize tool and the lighting effects filter. The national flower, details from the coat of arms, koalas, kangaroos, and birds were cut out and placed on top of the burgundy border using layers in multiply mode. The center scene was given a once over using adjustment layers to correct the color balance and enhance the arbor and surrounding leaves.

Lastly, the towel scans were added. Clark carefully adjusted the blending and opacity until the animals became "tapestry," joining the other ornamental details and the scene of the couple kissing. As the towel was beige, tending to dampen the color saturation of the images, final adjustments to it were made using adjustment layers so the tapestry can be seen in all its splendor.

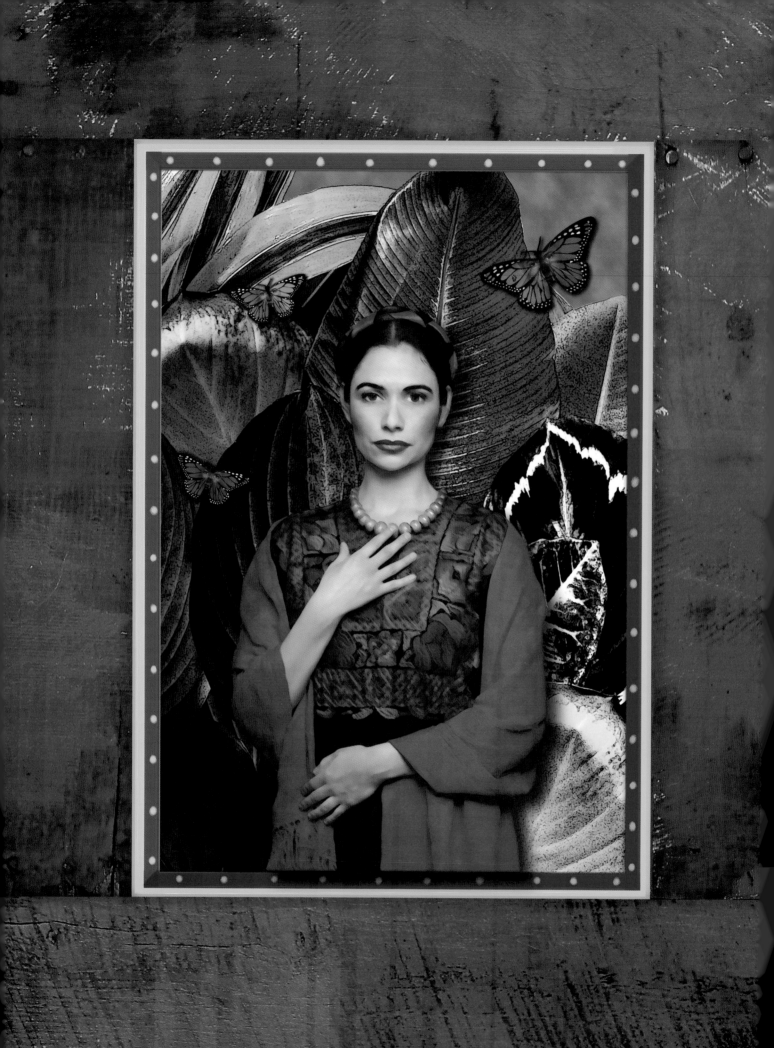

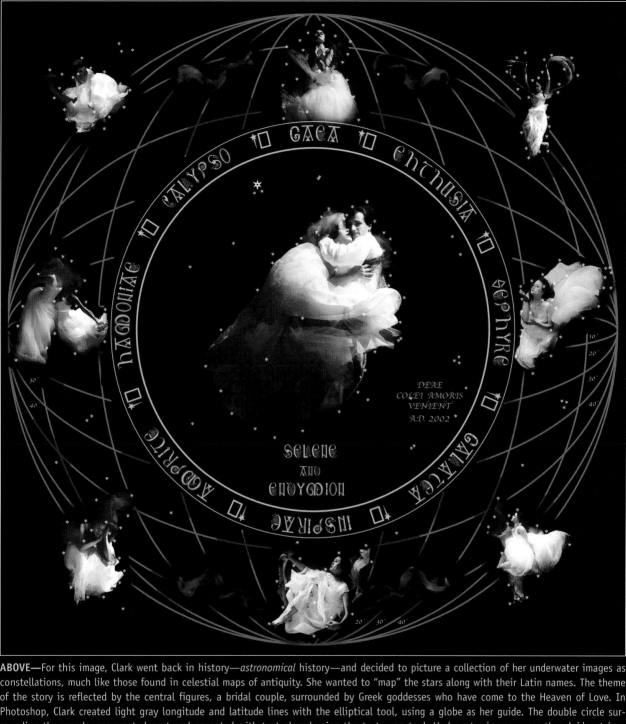

ABOVE—For this image, Clark went back in history—*astronomical* history—and decided to picture a collection of her underwater images as constellations, much like those found in celestial maps of antiquity. She wanted to "map" the stars along with their Latin names. The theme of the story is reflected by the central figures, a bridal couple, surrounded by Greek goddesses who have come to the Heaven of Love. In Photoshop, Clark created light gray longitude and latitude lines with the elliptical tool, using a globe as her guide. The double circle surrounding the couple was created next and accented with text placed using the text wrap tool. Underwater images were then laid out in a clockwork fashion. Lastly, stars were added using Zingbats (a symbol font). A north star was included to lend authenticity. The result, *Love's Star Charted Course,* surpassed even her original expectations. This image has won numerous awards, including a place in the ASP Traveling 100 Collection.

FACING PAGE—This collaboration started when Clark met Lilly, a Mexican multimedia artist who was born on the day artist Frida Kahlo died. She asked Clark to create a special piece for her in the manner of Frida Kahlo. Upon reviewing the images of Lilly in her native dress, Clark felt that she looked almost religious. After speaking with her friend, she decided the portrait would be *Our Lady of the Arts*. The piece recalls *Our Virgin of Guadeloupe,* a humbly framed image that is held in a place of honor and used frequently for parades. In Clark's image, the altered leaves illustrate growth. The butterflies are emblematic of the growth and transformation of artists—as well as a very important event in Mexico: the annual migration of the Monarch butterflies. You'll even see Lilly's eyes in the wings of the butterflies. The butterflies were cut out and colorized in Photoshop, then placed near the image of Lilly, floating at different heights within the space. Lastly, Clark photographed raw strips of wood that had been roughly painted in bright red. In Painter, she added the interior yellow and blue borders. These strips were then roughly assembled in Photoshop, complete with nails and nail holes. The frame pieces were printed on Crane Museo Rag Paper, and each section was scored, producing the look of bevels from the red area to the yellow dots on blue.

well known for his exotic car calendars, which he produces
annually and sells on his website (www.wendtworld

images of their vehicles.

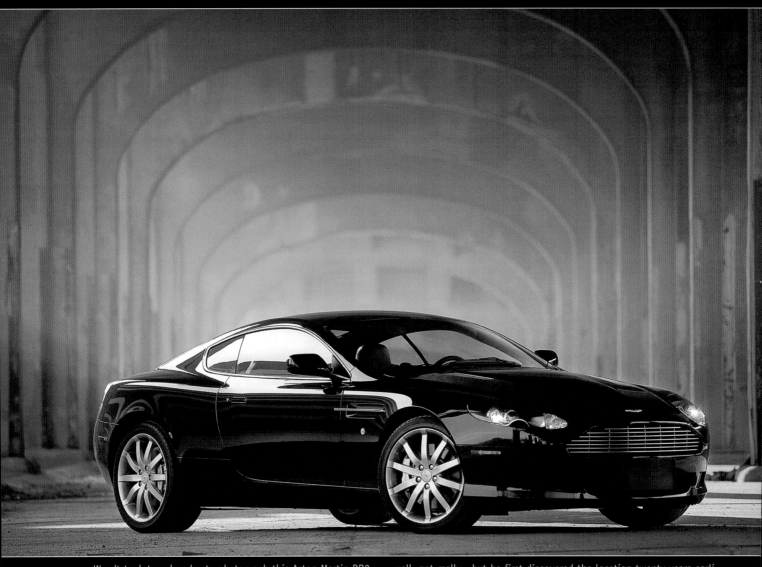

Wendt took two decades to photograph this Aston Martin DB9 . . . well, not really—but he first discovered the location twenty years earli-
er and had never used it until he discovered the right time of year (May), the right day of the week (Sunday, when nobody was around), and
the right time of day (very early morning). He always knew this location was capable of producing an incredible image, so he had to wait for
the right car, as well. The Aston Martin, with its long, low lines and glass-like paintwork, proved to be the secret ingredient. Wendt used a
Canon EOS-1Ds Mark II, 70–200mm f/2.8 Canon lens at the 200mm setting, and RAW mode. He used Photoshop CS to blend and build the
highlights in the bodywork and multiple layers to house each phase of the artwork.

He generally shoots with the Canon EOS 1Ds. In this case, once the sun went down, he started making images of the beautiful 1970 Chevelle shown below.

Wendt then processed the RAW file in Phase One's Capture One software to get a very good high-resolution base image. According to Wendt, this is where the real fun (work) begins. In Photoshop, he began by building layer upon layer with little bits of new, enhancing colors and contrasts to bring up the brightness in the reflections and take down areas of shadow to help make the car really pop. He also worked on the sky, which always needs better, richer color, he says. He made a selection of the sky using the color range tool, then added color by first making a new layer and applying a gradient.

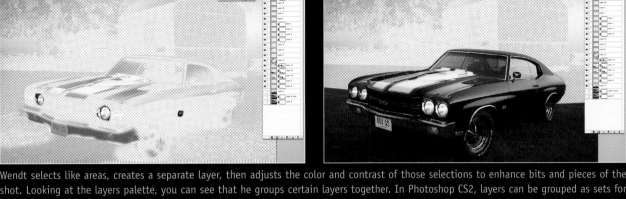

Wendt selects like areas, creates a separate layer, then adjusts the color and contrast of those selections to enhance bits and pieces of the shot. Looking at the layers palette, you can see that he groups certain layers together. In Photoshop CS2, layers can be grouped as sets for convenience and better workflow.

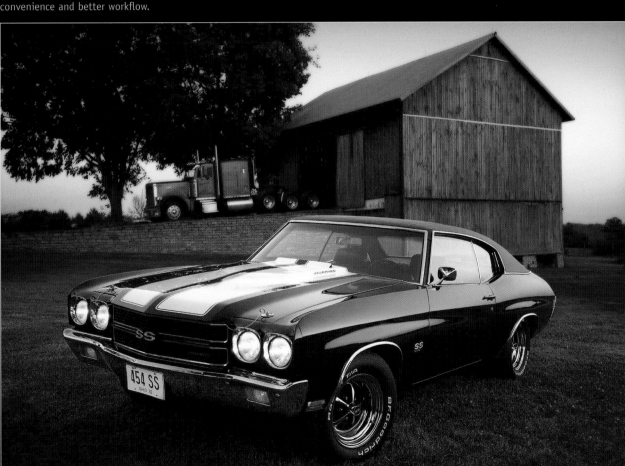

Final version of the 1970 Chevelle by David Wendt.

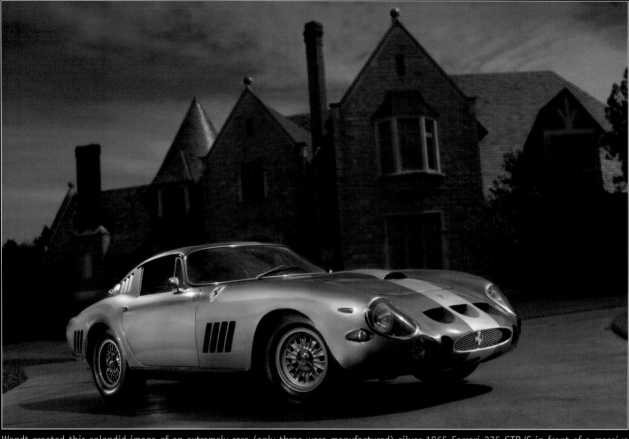

Wendt created this splendid image of an extremely rare (only three were manufactured) silver 1965 Ferrari 275 GTB/C in front of a massive English manor, which was actually in Dallas, Texas. Using a Canon EOS-1Ds and 50mm lens locked down on a tripod, he made nine identical exposures at $1/_{250}$ second at f/22. With each exposure, he lit the car from a different angle using a 400 watt-second strobe. Wendt downloaded the images, then used Photoshop to drag each of the separate images into one file with multiple layers. After the sandwich was completed, Wendt realized he had missed lighting a few spots on the front fender of the coupe. He retouched those spots by creating new layers and sampling existing colors and painting them onto the car. To work on each precise portion of the car he needed to retouch, Wendt employed the pen tool to create an additional five to ten smaller layers.

Wendt captured this 1970 Dodge Challenger T/A with a handheld Canon EOS-1Ds and 70–210mm lens and an exposure of $1/_{800}$ second at f/5.6. In order to capture the yellow speed bump in the foreground, he got down on the hot blacktop and placed the camera close to the ground. Wendt used Photoshop to tweak the yellow school-bus colors and darken the upper corner of the sky. To do this, he utilized the color range selection tool in Photoshop.

When working on an image, Wendt frequently uses the pen tool to make a quick, very accurate outline of the car. He feels it's the best way to get smooth-line selections. He also feathers each selection (maybe 1 to 2 pixels), since a hard edge might show up in the final version.

Wendt also creates selective contrasts throughout the image using blurring techniques and the blending modes (multiply, darken, etc). According to Wendt, "When you play with the blending of layers and colors . . . you can start to build levels of contrast that bring about the 'snap, crackle, and pop.'" Working with selections of the shine on the car, he paints into them with contrast-increasing colors, then uses the blending modes to provide even more contrast—a great effect.

RIGHT—Wendt often photographs trucks at night so he can show the lights that adorn today's behemoths. He places strobes in unusual places in order to get eye-catching results. Here, one was positioned in front of the driver to record his portrait in the long exposure.

BELOW—To shoot this 1934 MG-NA, Wendt rigged a mounting system to position a camera close to the moving car (which he towed with his Audi) and shot two rolls of 220 film. He had a sharp image and a blurred one drum scanned, then combined them in Photoshop. Using layers, he erased the blurred image of the car but left some of the other blurred areas alone to convey fast motion. He also rebuilt the area in Photoshop that showed the rigging and camera support.

PHOTOSHOP TECHNIQUES

Adobe Photoshop is much more than a powerful program for editing image files, it is a virtual digital darkroom that offers more creative flexibility than a conventional darkroom. And better than darkroom work, Photoshop allows you to work on the image as a positive (rather than a negative) so you can view the effect as you create it.

Photoshop's flexibility also makes it open to a wide variety of unique creative techniques. In fact, if you sit down with six photographers and ask them each how they do a fairly common correction, like selective diffusion, you just might get six completely different answers. Many practitioners pick up one technique here and another at a workshop they've attended and, the next thing you know, the two techniques have become hybridized to produce a slightly different result than was yielded by either of the original methods.

LEFT—Craig Minielly shoots all his originals for maximum detail. This image was shot in RAW mode with camera tone set to low, all sharpening off, and exposure set to retain highlights. **RIGHT**—Here you see three of Craig's Actions used on the same portrait: PortraitPopper Light, Facial Enhancements, and PorcelainSkin (Opacity at 60 percent, subject details brushed back in). Image sequence by Craig Minielly, MPA.

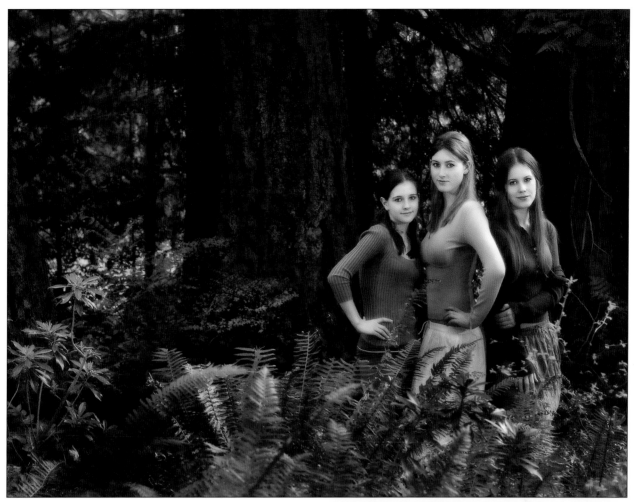

RIGHT—Here, the original image is flat and there is no real modeling to the lighting on their faces. **ABOVE**—In this image, we see a number of actions in use: PortraitPopper, ShadowSoft Natural, Facial Enhancements, PorcelainSkin, DarkEdge Strong, Fashionizers Strong, UnsharpMask Medium. Selective darkening was also applied around the subjects and bright areas with local lightening on subjects. The edge details were enhanced with Fashionizer's built in masks. Image sequence by Craig Minielly, MPA.

The following is a collection of Photoshop techniques gleaned from the photographers who appear in this book.

◘ Actions

Photoshop actions are scripts that contain a series of commands. The Actions palette is accessed under the Window menu.

Photoshop comes with a variety of preloaded actions you can use as is or customize to meet your needs. You can also purchase actions from reliable sources on the Internet to utilize the experience of

some of the best Photoshop practitioners in the business. For example, Fred Miranda has a site (www.fred miranda.com) that contains a wide variety of excellent actions at reasonable prices. Two of Miranda's more noteworthy actions are SI Pro II (short for Stair Interpolation Pro), which allows you to increase file size and dimensions, and Intellisharpen II, which

is a smart-sharpening action that gives you 12 sharpening options with full previews.

Craig Minielly, MPA is the designer of Craig's Actions (www.craigsactions.com), an extensive library of image-altering effects with many of the built-in subtleties that one would expect from a professional imaging product. Each action takes a snapshot of your image and retains it in the history palette, allowing you to play with the actions all you want without damaging your source files. Additionally, many of the actions produce built-in layers with opacity sliders that allow you to further adjust the effect after running it. It would be impossible to list all the variations, but the following are a few of Craig's Actions that are especially useful for portraits:

- Fashionizers provide an "edgy" feel. This works well with images that have a lot of edges and textures.
- StoryTellers 1 and 2 are ideal for editorial images, fashion photos, and senior portraits.
- ShadowSoft Grainy works well for wedding and fashion images.
- PorcelainSkin is a selective softening action with full multi-layer control over intensity and placement.
- Productivity Essentials is a good starting point for all of your production tasks.
- Facial Enhancement is a multilayer action for enhancing eye features and correcting problem teeth.
- Glamour Blur is a highlight diffusion action with a mask control layer.
- Illustration Blur is an airbrush-style action with full mask control.
- Cross-Process simulates E-4 to C-41 processing and vice versa.

You can also record your own custom actions, then play them back to apply the identical operations to another image or set of images. To do this, select "new action" from the drop-down menu at the top right of the actions palette. You will be asked to name your new action, then Photoshop will start recording. Once recording, everything you do to the image will be recorded as part of the action. When done, simply stop recording by pressing the square button at the bottom of the actions palette. Whenever you want to perform that action on an image, open the image file, locate the desired entry in the actions palette, and hit the play button (the triangle at the bottom of the palette).

Most commands and tool operations are recordable in actions. For those that cannot (for instance, brush strokes with a painting tool), you can include stops that pause the process and let you perform the tasks before continuing on with the recorded steps. Actions can also include modal controls that let you enter values in a dialog box while playing an action.

▣ Layers and Masks

Layers allow you to work on one element of an image without disturbing the others. Think of layers as sheets of clear acetate stacked one on top of the other; where there is no image on a layer, you can see through to the layers below. You can change the composition of an image by changing the order and attributes of layers. In addition, special features such as adjustment layers, fill layers, and layer styles let you create sophisticated effects.

Masks control how different areas within a layer or layer set are hidden and revealed. By making changes to the mask, you can apply a variety of special effects to the layer without actually affecting the pixels on that layer. You can then apply the mask and

SAVE AS
Always save both a layered version (.PSD file) and a flattened copy of your image. If you just flatten and save your file, you'll lose the ability to (easily) change it later. Having saved two versions, you can then use the flattened image in other applications, such as Adobe InDesign, but you will still have the PSD version in case you decide to make changes in the future.

make the changes permanent or remove the mask without applying the changes.

Working with Layers. Layers are one of the most flexible tools in Photoshop. You should get into the habit of naming each layer as you create it. This will help you to organize and work with multiple layers. Just double-click on the layer name to rename it with up to 63 characters.

You should also make it your practice to duplicate the background layer before getting started working on an image. This preserves the original, which floats to the bottom of the layers palette. It also opens up creative possibilities, allowing you to alter the new layer and then lower its opacity to allow the original to show through. The eraser tool can also be useful when working on a duplicate of the background layer. For example, you can apply the posterize command (Image>Adjustments>Posterize). This will affect the entire image, but if you want to retain the photorealistic portions of the portrait, you can use the eraser tool to reveal the underlying background layer. By adjusting the opacity, you can blend the effect with the underlying data.

On many images, you will end up with quite a few layers. If you need to move them around, it's a good idea to link them together. With one of the layers active, click to the left of the layers you want linked and a chain-link symbol appears. Linked layers can be moved or affected all at once. Clicking the chain-link symbol again will unlink the layers.

If you have many layers in your document, layer sets (folders that contain layers) can help keep you organized. To create a layer set, click on the little folder at the bottom of the layers palette to add an empty folder, then drag layers into it. You can also create a set by linking a series of layers together and then choosing New Set from Linked from the drop-down menu at the top right of the layers palette.

Using Layer Masks. Layer masks are used to temporarily hide portions of a layer. To create a layer mask, activate a layer (other than the background layer) and click on the layer mask icon (the circle in a square) at the bottom of the layers palette. A second thumbnail will appear beside the layer in the layers

Layers Palette Enhancements
A Linked layers indicator
B Normal layer thumbnail
C Smart Object thumbnail
D Link layers button

The layers palette with call-outs, explaining the different icons and features found in Photoshop CS2.

palette. With black as your foreground color, you can then use the brush tool to paint away (conceal) details in the upper layer, allowing the underlying layer to show through. To reveal the hidden areas again, change the foreground color to white and paint the areas back in.

■ Plug-Ins
Plug-ins are software programs developed by Adobe, and other software developers in conjunction with Adobe Systems, to add features to Photoshop. A number of importing, exporting, and special-effects plug-ins come with Photoshop; they are automatically installed in the plug-ins folder.

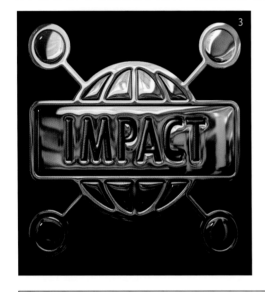

FACING PAGE—(1) Brushed Metal renders architectural surfaces, such as stainless-steel diner walls, copper counter tops, and colorful anodized aluminum. Brushed Metal offers three brush patterns (linear, circular, and handbrushed) to imitate many etched metals. All photographs courtesy of Eye Candy except where noted. (2) Bevel creates a wide variety of embossed, carved, and beveled shapes. Bevel imitates shiny embossed metal. With new surface textures, Bevel also renders pitted, bumpy, and craggy objects. (3) Chrome simulates mirror-polished chrome, liquid metal, and other shiny surfaces. (4) Featuring reflection map technology, Chrome yields realistic reflections. Users can even import their own reflection maps. Motion Trail creates semi-transparent streaks along a flexible path. An in-preview control precisely steers the streak. Objects can turn, swerve, blast off, descend, or even travel in a straight line. Photograph by Bill Hurter. (5) Perspective Shadow creates 3-D perspective and drop shadows, as well as reflections. The two modes are separated to simplify use. (6) Super Star allows users to create many new shapes, including gears, flowers, spirographs, and more. Super Star also provides color-management tools for tinting the shapes. Super Star includes a color gradient editor for tricky work and options for radiating colors from the edge or center of the stars.

You can select an additional plug-ins folder to use compatible plug-ins stored with another application. Alternately, you can create a shortcut (Windows) or an alias (Mac) for a plug-in stored in another folder on your system, then add the shortcut or alias to the plug-ins folder to use it with Photoshop.

Once installed, plug-ins appear as options added to the import or export menu, as file formats in the open and save-as dialog boxes, or as filters in the filter submenus. Photoshop can accommodate a large number of plug-ins. However, if the number of installed plug-ins becomes too great, Photoshop may not be able to list all the plug-ins in their appropriate menus. Newly installed plug-ins will then appear in the Filter>Other submenu.

Eye Candy 5 Impact is a collection of ten third-party Photoshop filters that allow you to create chrome, bevels, glass, perspective shadows, brushed metal, and extruded edges (see facing page)—as well as some other mind-boggling effects. Below are some of the effects found in Eye Candy Impact.

■ Retouching Techniques

Removing Blemishes. To remove small blemishes, dust spots, marks, or wrinkles, select the healing brush tool (or, if using Photoshop 6 or lower, the clone tool). When this tool is selected, an options bar will appear at the top of the screen. Select the normal mode and sampled as the source. Choose a soft-edged brush that is slightly larger than the area you are going to repair. Press Opt/Alt and click to sample a nearby area that has the same tone and texture as the area you wish to fix. Then, click on the blemish and the sample will replace it. If it doesn't work, hit Command + Z (Edit>Undo), then resample another area and try again. The healing brush differs from the clone tool in that the healing brush automatically blends the sampled tonality with the area surrounding the blemish or mark.

Shininess and Wrinkles. These two topics are lumped together because fixing them is easily done using the same tool and technique. The clone tool, used at an opacity of about 25 percent, is a very forgiving tool that can be applied numerous times in succession to restore a relatively large area. The mode should be set to normal and the brush should, as usual, be soft-edged. As you would when using the healing brush, sample an area by hitting Opt/Alt and clicking once. A fleeting crosshair symbol shows the sampled area as you apply the tool.

For both wrinkles and areas of shininess, sample an adjacent area with the proper tonality and begin to rework the area. You will find that the more you

Color Mode and Retouching

Even if the final destination for your image is the CMYK color space (for offset printing, for example), all of your retouching and color corrections are better handled in RGB. The CMYK color space has a limited gamut (range of colors) as compared to RGB. The more you work on an image in CMYK, the more anomalies will occur. If you spend a lot of time and effort retouching and color correcting an image, it would also be wise to save a finished RGB version for future use—before conversion to CMYK. Also, many filters won't work in CMYK. A good rule of thumb is to do all of your work in RGB mode, then make converting to CMYK the final step in your process.

BRIAN KING'S SENIOR RETOUCHING

Brian King is an expert senior photographer with a thriving business. His seniors come from miles around because of the great treatment and top-notch images he provides. On retouching, which is more basic than one might think, he says, "Our normal client work gets basic retouching to remove blemishes and soften facial lines. Typically, there is no major wrinkle or crease work done unless requested by the client. I am not that proficient in Photoshop, so my techniques would probably send chills down the spines of those in the know. Basically, I take the images a bit further than the lab by adding additional work under the eyes and smoothing out facial areas that have larger pores. My favorite treatment so far is to clean up the whites of the eyes with either the brush tool or the dodge tool and then deepen the existing eye color. I have been having fun playing with the saturation levels and also the Gaussian blur filter to create a more defined selective focus."

TOP—With an 80–200mm zoom at the 185mm setting, Brian King chose to isolate the eyes and frontal mask of the girl's face. King does minimal retouching—a little on large pores, blemishes, creases, etc.—but prefers to allow the character of the individual to come through. This is a very pleasing portrait that I am sure both the subject and her parents thoroughly enjoy. BOTTOM—Brian King knows exactly what seniors want to see in their portraits: they want to look like themselves. King's elegant lighting, minimal retouching, and close-up viewpoints provide just the "edginess" that make his portraits a big hit with senior clients. This image was shot in RAW mode. In processing, Brian increased both the contrast and brightness and did a little color-noise reduction to counteract the effect of the ISO 200 setting. The image was shot with a Fuji Finepix S3 Pro and 85mm f/1.8D AF Nikkor lens at f/3.3.

apply the cloned image data, the lighter the wrinkle becomes or the darker the shiny area becomes. Be sure to zoom out and check to make sure you haven't overdone it. It is important not to remove the highlight or wrinkle entirely, just subdue it. This is one reason why it is always safer to work on a copy of the background layer instead of the original image itself.

Eyes and Teeth. By quickly cleaning up eyes and teeth, you can put real snap back into the image. Use the dodge tool at an exposure of 25 percent. Since the whites of the eyes and teeth are only in the highlight range, select highlights from the options bar.

For the whites of the eyes, use a small soft-edged brush, but do not overdo it. For teeth, select a brush that is the size of the largest teeth and make one pass.

BRYAN WHITE: MIXED MEDIA ARTS

Bryan White is a photographer and painter who specializes in mixed media pieces that are designed to affect the viewers' emotions.

As he says on his website (www.cultureshock.biz), his art is about human-interest themes. "We are about impact and influence," he says. His artwork is marketed to those looking for one-of-a-kind originals—to those "who are not satisfied with the mundane, who believe in visual equivalents for their feelings, and who indulge in the wisdom of a child."

According to Bryan, "A mixed-media photographic collage can only be effective in stirring the viewer's emotions if it first has a well thought out, meaningful concept." The accompanying image called *Determination* (see below) is a

Determination is a collage made up of numerous images combined in Photoshop and then hand-rendered with traditional artist's tools. It depicts a special child's overpowering will to succeed athletically despite overwhelming physical obstacles.

Extreme Dance is the title of this hand-painted and hand-drawn collage. White used various photographic studies at different film speeds and constructed the various images with Photoshop layers in a panoramic format. He then output the page on watercolor paper and used acrylics and pencils to produce the final result.

Disney ABC is a self-assignment for Bryan White's two year old. On a vacation to Disneyland, White discovered the alphabet and numbers in elements in and around Disneyland. He montaged the different images in Photoshop to produce an imaginative primer for his child.

Iguana is a collaboration of images, each with the sole objective of introducing texture. The rusted steel base with side lighting enhances the natural texture of the iguana's skin. Dragonflies and lots of color were introduced to the composition to create a full spectrum of color.

Standing Out in the Crowd is an exercise in design and color dominance. The image is composed of four horizontal panels with seemingly dissimilar subject matter—sushi chefs, brownstones in Manhattan, fish at the fish market and parked cars on the street. The dissimilarity and monotony are broken by the use of one red element per panel, making the eye leap from color to color, indifferent to the subjects. White used Photoshop to create not only the effects, but the collage of images. A black background unifies the amazing composition.

Never Forget is an homage to the true heroes of September 11, 2001, the fallen firefighters and policemen who fought to save the victims of the terrorist attack. Bryan White montaged original images in Photoshop and then adjusted the various layers' opacity and transparency to create a cohesive memory of the heroes of the day.

portrait of Zach Bobowski, a teenage athlete. Zach was born with spina bifida and though confined to a wheel-chair, he does not consider himself disabled, because it is all he has ever known. Zach's dream is to one day compete in the Paralympic Games. The image showcases Zach's inner drive to succeed, his will to perform and overcome, and his desire to be the best. Bryan's strategy was to capture many different angles of Zach speed-training so the collage would have a distinct flow.

Bryan used a combination of different films, including T-MAX 3200, for the collage. He wanted some sharp and some out-of-focus images to work with. He selected the strongest images to create the greatest visual impact.

Once the images were selected, he drafted a rough layout that would allow him to determine the overall flow and where the points of interest would be located.

After modifying many versions of the layout, the final images were scanned and put together more precisely in Photoshop. The final step was to output the file on water-color paper and hand-render the image using acrylics and charcoal pencils.

Bryan thinks of Photoshop as a layering tool to help him place his "elements." He prefers outputting the image onto watercolor paper and then applying other media directly to the print for a more hand-finished, not-digi-tized look.

Notice how beautifully the skin in this image is blended. The sharp features—lips, eyes, eyebrows, etc.—are carefully handled so that no retouching is visible. Photograph by Marcus Bell.

For really yellow teeth, first make a selection using the lasso tool (it doesn't have to be exact). Next, feather the selection. Then go to Image>Adjustments>Selective Color. Select neutrals and reduce the yellow setting, making sure the method mode is set to absolute, which gives a more definitive result in smaller increments. Remove the yellow in small increments (one or two points at a time) and gauge the results in the preview. You will instantly see the teeth begint to whiten. Surrounding areas of pink lips and skin tone will be unaffected because they are a different color.

Selective Soft Focus. Selective soft focus is one of the most frequently used retouching effects in wedding and portrait photography. To create it, duplicate the background layer and apply the Gaussian blur filter to the new layer. Click the layer mask button to create a mask. With the brush tool selected and the foreground color set to black, start painting away the diffusion from areas like the teeth, eyes, eyebrows, hairline, lips, and bridge of the nose. By varying the opacity and flow you will restore sharpness in the critical areas while leaving the rest of the face pleasingly soft. The best thing is that there will be no telltale sign of your retouching.

Soft Focus. Once all your retouching is done, merge the visible layers (Layer>Merge Visible). This takes everything you've done so far and reduces it to a single layer. Duplicate this layer, then apply the Gaussian blur filter with a radius setting of about 25 pixels, so that the entire image is blurred. Reduce the opacity to about 50 percent for a true soft focus lens effect, a soft image atop a sharp image. Using a layer mask, you can selectively restore sharpness to the eyes, lips, eyebrows, and hairline. Then, select a large brush (about the size of the face) and set it to a low opacity (about 5 percent). Touch the face with the brush once or twice to bring out just a little more overall detail.

Vignetting. Make a new layer and fill it with black. Adjust the opacity back to about 35 percent so that the image looks dimmed. Add a mask to the layer and then, using a black-to-white gradient with the gradient tool, click near the eyes and drag outward toward the image edge and release the mouse. The result will be a full vignette with the face lighter than the edges of the image.

These tips are courtesy of Claude Jodoin's Click to Print Workflow series of educational CDs, which are available from www.claudejodoin.com.

Minimize Retouching. Tim Schooler is an award-winning photographer specializing in high-school senior photography with a cutting edge. He always shoots in RAW mode, then converts his files in Phase One's Capture One. His work is noted for the "pop" in the eyes and for the generally incredible way that he treats the faces he works with. He says, "I am not a fan of over-softening skin, I think it is done too much these days. But with digital, and the

This before-and-after example includes the techniques described on pages 82 and 84. The original digital image was so sharp that it needed softening so that the face would not be so incredibly detailed. Even people with exceptional eyesight do not experience others' features in this way. Photographs by Claude Jodoin.

The delicate vignetting around this baby was done with methods similar to those described on the facing page. Instead of a duplicate layer, however, an adjustment layer (which comes equipped with a default mask) was created above the original background layer. The image was then darkened with the hue/saturation controls. With the foreground color set to black and a soft-edged brush, the original tonality was carefully painted back in. Careful adjustment of the brush opacity and fill are required for the smoothest blending. Photograph by Marcus Bell.

CLAUDE JODOIN'S FACIAL RETOUCHING

Blemishes—Enlarge the face to 100 percent and choose the patch tool. Then, surround the blemish and drag it to an adjacent area of skin. This will maintain the same general color and texture of the skin.

Smoothing the Skin—Make a rough selection around the face, then copy and paste it to a new layer. Using a filter called Airbrush Gem Professional from Kodak, Jodoin uses a default value of 60 percent to airbrush the sharpness and pores out of the face. If you go too far, reduce the opacity in the layers palette. To disaffect certain areas, create a mask and paint on the areas with black that you want to be masked (concealed).

Smooth Skin (Alternate)—Duplicate the background layer and add 4 pixels worth of Gaussian blur. After adding a layer mask, go to Edit>Fill>Black to unmask the entire layer so that you can see through to the retouched layer underneath. Using about 35-percent opacity setting on the layer, set the foreground color to white and brush the softness back in (unmask it) with a medium-sized brush. If you overdo it, go back to the Layers Palette and reduce the opacity by about 10 percent, then inspect your results again.

Eyes—Create a curves adjustment layer and lighten the overall image by about 20 percent. With the adjustment layer, a layer mask will automatically be created. Go to Edit>Fill>Black to mask the entire layer. With white as the foreground color, paint over the eyes to lighten them. For a natural and realistic look, you should not, however, make them completely white, nor should you entirely eliminate the natural blood vessels. To increase the color contrast between the pupil and the iris, create a second curves adjustment layer and darken the image slightly. Repeat the rest of the technique as described above, painting over just the pupils to darken them.

More on Eyes—Using a small brush and the dodge tool set to highlights or midtones, you can lighten the whites. With the burn tool and a small brush, you can lighten the interior of the iris, but not the edge. This increases the edge contrast in the iris for a more dynamic look. Also burn in the pupil with black to make it more stark.

 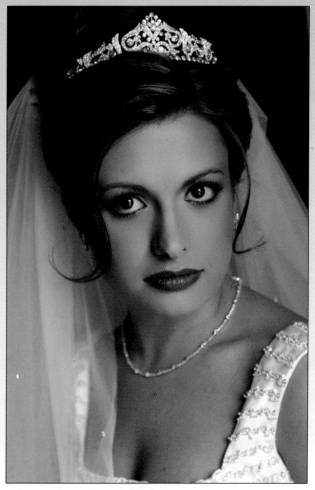

This bridal portrait was retouched using the techniques described below. Photographs by Claude Jodoin.

high-resolution sensors we're using now, you have to do a subtle amount of diffusion to take the edge off. But I still want to see detail in the skin, so I'll apply a slight level of diffusion on a layer, then back if off until I can see the pores."

One of Schooler's settings in Capture One is for high-contrast skin tones and a 7 percent increase in color saturation. This gives his finished images a little more color, an effect he says seniors like a lot. [*Note:* Capture One has four options to emulate the look of film. Schooler uses a custom profile from Magne Nielson for skin tones. In Capture One, you can set the default film type to linear response, film standard, film extra shadows, or film high contrast. Schooler used to use the film standard setting but found he was tweaking the curves too often to achieve more punch. Now he uses film high contrast and he finds it's a lot closer to Portra VC, which was his preferred film before his studio went digital.]

"My goal is to shoot everything as a finished image—in fact, that's how I proof. Nothing is edited or retouched before the client sees it. Then we retouch only what they ask for." He continues, "I have always felt that Photoshop should be icing, just a finishing touch after first baking a good cake. It's a corny analogy, but I really think it fits. More and more, photographers seem to just shoot and fix it later in Photoshop. With the volume we had this year, there is no way I could spend that much time in Photoshop on every image—even if I wanted to."

BELOW—Tim Schooler is well known for his treatment of the eyes, which are white and contrasty. Some might feel they're too clean, but for seniors, it's a terrific look. He likes to soften the image just slightly and then bring the image back so the pores are visible. **NEXT PAGE**—Schooler, who shoots mostly seniors, selects a higher contrast setting for his RAW file processing in Phase One Capture One.

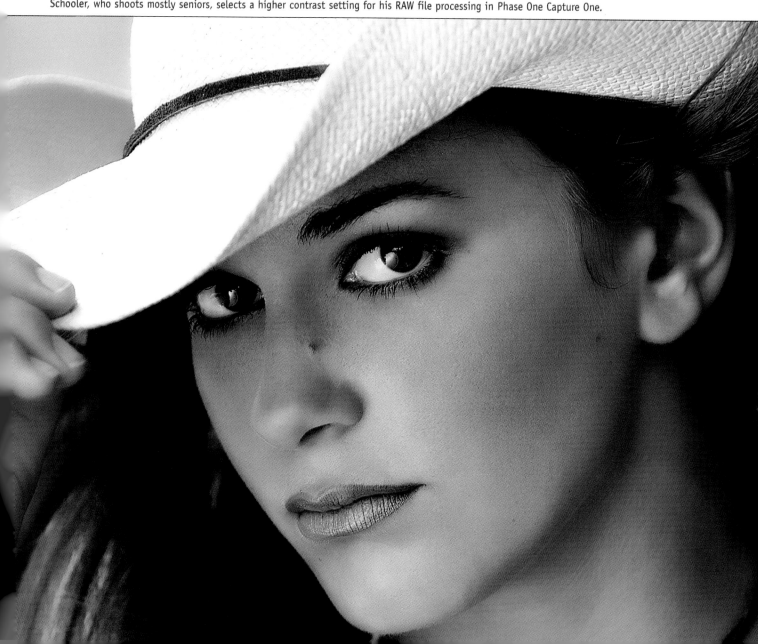

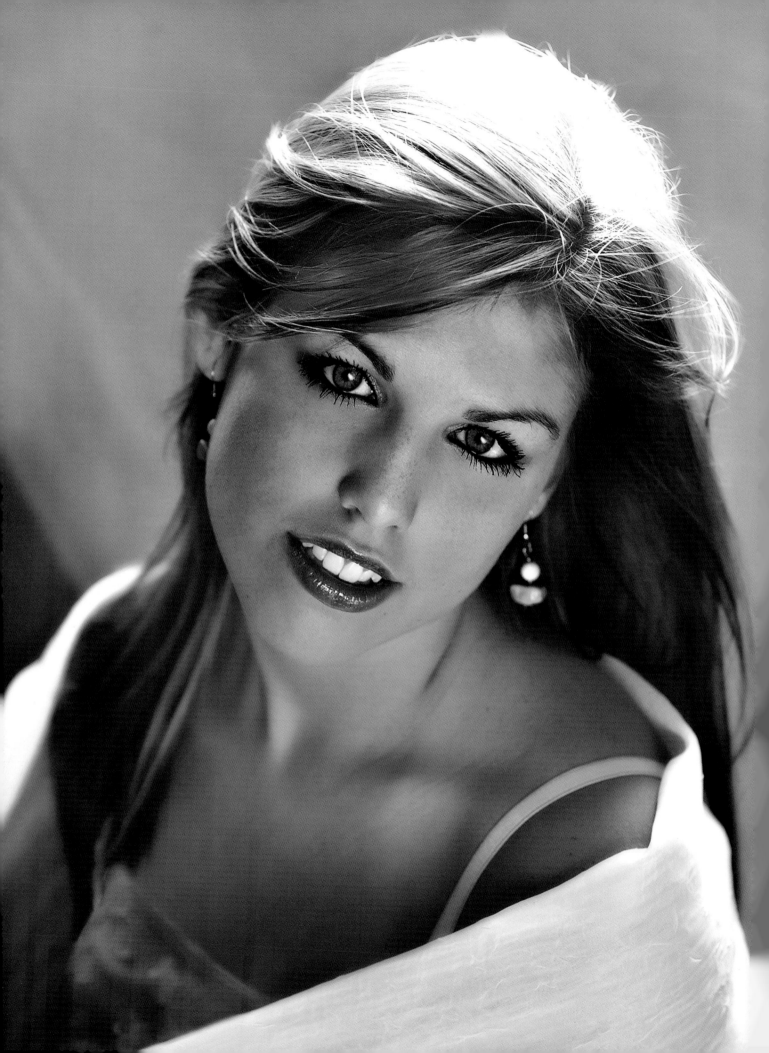

One of the things Ctein likes best about the new world of digital photography is the way it "enhances the conventional photographic experience." A veteran darkroom professional, master printer, and author of countless technical articles about the darkroom, Ctein says, "I'm still a film-oriented photographer. Even when I make the switch to digital cameras, I'll still have a huge body of film-based photographs."

It was inevitable that his three decades of interest in photo preservation and digital technology would merge in a career. Digital restoration, he believes, is safer and faster than traditional restoration because all the restorative work takes place in the computer. "Most importantly, it's usually better," says Ctein.

At first, he did restoration simply for his own enjoyment and then for the pleasure of resurrecting friends' cherished photographs. Now, it's become part of his business (http://photo-repair.com), but it's also immense fun for him. "I can combine my decades of photographic printing skill and experience with high-tech tools to construct a new digital image that embodies the orig-

inal quality and beauty of the photograph. It's genuine 'information recovery,' not 'information fabrication,'" he says.

A friend of Ctein's, Brooks V. Walker, photographed this mid-1970s landscape (see below) on early Kodacolor II color negative film, a relatively unstable film. The original negative had faded severely; most of the yellow dye and easily half of the cyan were gone. Also, the fading was uneven across the negative. It also had some light scratches but no serious damage.

According to Ctein, this negative was unprintable. The best possible darkroom print he could make (lower left)

This 35mm Kodacolor II negative was badly faded after 30 years of room-temperature storage. Conventional darkroom printing (lower left) could not rescue it; there's too much loss of density and severe color crossover caused by differential fading of the dye layers. Digital restoration (lower right) produced an entirely satisfactory print from this "hopeless" negative.

Original Color Negative

Conventional Print

Restoration

photograph by Brooks V. Walker

The original (upper) photograph is torn, stained, and faded and has substantial emulsion damage. Fine cracks cover the entire surface, as you can see in the greatly enlarged section at right. In the digitally restored version (lower), you can see how the cracks are greatly diminished without fine detail being destroyed.

was still very dark and low in contrast, and it suffered from extreme and uncorrectable color distortion, with purple shadows and green highlights.

This negative needed to have density and contrast restored to the cyan and yellow dye images so that they matched the magenta dye image. To deal with the uneven fading, Ctein created two curves adjustment layers, one to fix the cyan dye fading and the other to fix the yellow dye fading.

These curves adjustment layers overcorrected portions of the negative that were less faded, so Ctein fixed the problem by using the airbrush tool, set to black and 10-percent strength, to paint in masks on each of the adjustment layers to reduce their effect on the portions of the negative that didn't need as great a correction. He also used the color sampler tool in Photoshop to set several information points in the negative so that he could monitor how the highlights, shadows, and midtones changed as he altered the curves.

Once the image had an overall approximation of correct contrast and color, he made local adjustments to the curve shapes, hue, and saturation. In consultation with the photographer, he also accurately restored the color and tonal values in the water and foliage. The final result is the photograph at the lower right.

The second example (above) shows an old family photo that is faded, stained, and missing entire chunks of emulsion. In addition, the emulsion has shrunk and shattered over the entire print, covering it with fine cracks.

Fixing the tone and color was easy. First, Ctein desaturated the image by 90 percent (to leave it with just a hint of antique brown). Next, he used the curves to restore the whites and blacks and adjusted the midtones for a good rendition.

The missing pieces of emulsion luckily fell in areas that were easy to fill in. However, dealing with the cracking took some ingenuity. Blurring or smoothing filters were out of the question, so he created a crack-selection mask by applying Photoshop's find-edges filter, inverting the selection, and blurring the result (which he saved in a new channel). He then created a duplicate layer of the original photo, applied that mask as a selection—picking out only the cracks—and ran Photoshop's median filter on it. The crack-selection filter wasn't foolproof; in some places it had picked up real image detail instead of just cracks. Consequently, there were small, isolated regions where the median filter had blurred out real detail. He eliminated those problems by painting a mask into the median-filtered layer that blocked the filter's impact at those edges. The result, while imperfect when viewed at high magnification, looks flawless at normal viewing distances.

◾ Color Correction and Toning

Targeting White and Gray Points in Levels. Go to levels (Image>Adjustments>Levels), select the white point eyedropper and click on a white point in the scene—a white point on the bride's wedding dress, for example. One click will not only color balance the whites, but it will bring any color shifts in the flesh tones back in line. The same technique will work well when using the gray point eyedropper (also in levels) on a neutral gray area of the photo.

When an image doesn't have a well-defined gray or white point, you cannot use this method of color correction. Instead, create a new layer and go to selective color (Image>Adjustments>Selective Color). Correct the neutrals by adding or subtracting the appropriate color(s), then adjust the opacity of the new layer. You will get more subtlety than if you tried to correct the entire image.

Selective Color. Many people like to use curves to color correct an image, but there are also those who prefer the selective color function (Image>Adjustments>Selective Color). It is among the most powerful tools in Photoshop. This tool does not require you to know in advance which channel (R, G, or B) is the one affecting the color shift. It only requires you to select which color needs adjustment—reds, yellows, greens, cyans, blues, magentas, whites, neutrals, or blacks. Once you've selected the color you want to adjust, use the slider controls (cyan, magenta, yellow, and black) to make the needed correction. (*Note:* Make sure the method mode is set to absolute, which gives a more definitive result in

smaller increments.) If, for example, you select reds, no other colors in the scene will be changed by any adjustments you make using the slider bars.

Skin tones are easy to correct using selective color, as well. Most caucasian skin tones are comprised of varying amounts of magenta and yellow. Usually when skin tones are off, they can be easily corrected by selecting neutrals, then experimenting with either the magenta or yellow sliders. In outdoor images, you will sometimes pick up excess cyan in the skin tones; this is easily dialed out in selective color.

The selective color tool is also useful for eliminating color casts on wedding dresses, which often reflect a nearby color—particularly if the material has a sheen. Outdoors, the dress might go green or blue, depending on whether shade or grass is being reflected into it. To correct the problem, select the whites. Then, if the dress is blue or cyan, add a little yellow or remove a little cyan and judge the preview. If the dress has gone green, add a little magenta and perhaps remove a slight amount of yellow.

In selective color, the black slider adds density to the image. Be sure to adjust only the black channel using the black slider, otherwise it will fog the image. When converting images from RGB to CMYK, the black slider is very useful for adding the punch that is missing after the conversion.

You can also create a selection and color correct only that area. For teeth, for example, a loose selection around the mouth will do; then adjust the whites by subtracting yellow. It's a quick and effective means of whitening teeth.

Kodak Color Print Viewing Filter Kit

If you aren't sure of the color shift in an image, there is a product available from Kodak for making color prints. It is called the Kodak Color Print Viewing Filter Kit, and is comprised of six cards—cyan, magenta, and yellow; and red, green, and blue. In a darkened room, inspect your image on the monitor using the card that is the complementary color of the indicated color shift. For example, if the shift looks blue, use the yellow card to view the image. If the color shift is green, choose the magenta card, and so on. Flick the appropriate card quickly in and out of your field of view, examining the midtones and shadows as you do so. Avoid looking at the image highlights; you will learn nothing from this. If the yellow card, in this example, neutralizes the color shift in the midtones and shadows, then you are on the right track. There are three densities on each card, so try each one before ruling out a specific color correction.

FACING PAGE—Parker Pfister visited New Orleans shortly after seeing Quentin Tarantino's *Kill Bill, Vol. II*. With the film's high-contrast images, the mood was set for Pfister to make some great photographs. He worked in layers with different level adjustments: one for highlights, one for midtones, and one for shadows. In addition, he also added layers for no-detail shadows and no-detail highlights. This created the mood that he felt when he snapped the shutter. If there was to be color in the photograph, it had to be very muted. His goal was to give these photographs personality; he wanted to show the dark side of life. To this image, he also added a transparent black vignette, which focuses your attention on the subject. **RIGHT—** Claude Jodoin created this wonderful image using the vignetting technique described earlier. He made a new layer and filled it with black. He then reduced the opacity to about 34 percent, so that the image looks dimmed. Next, he added a mask to the layer. Using black with the gradient tool, he clicked on the eyes and moved the second point outward toward the image edge. The result is a full vignette with the face lighter than the edges.

Sepia/Blue Tone. Create a copy of your background layer, then go to Image>Adjustments>Desaturate to create a grayscale image. Adjust the levels at this point, if so desired.

Next, go to selective color (Image>Adjustments>Selective Color). Select the neutrals channel and adjust the magenta and yellow sliders up. More magenta than yellow will give you a truer sepia tone. More yellow than magenta will give a brown or selenium image tone. The entire range of warm toners is available using these two controls.

If you want to create a cool-toned photograph, either add cyan, reduce yellow, or do both. Again, a full range of cool tones is available in almost infinite variety.

Once you have created a number of image tones you like, you can create actions for them, specifying the exact values for each adjusted color.

Mixing Color and Black & White in the Same Image. A popular effect is to add bits of color to a monochrome image. To do this, simply copy the background layer and desaturate it by going to

Image>Adjustments>Desaturate. Go to the levels control (Image>Adjustments>Levels) to adjust brightness and contrast to your liking. With the eraser tool set to a small- to medium-sized soft brush and the opacity set to 100 percent, start to erase the areas you want to be in color. The color from the underlying background layer will show through the erased areas.

Soft Color. This is a technique that mutes the colors in an image. To achieve it, duplicate the background layer and convert it using Image>Adjustments>Gradient Map. Choose a black-to-white gradient for a full-tone black & white image. Blur the underlying color layer using the Gaussian blur filter with a radius setting of about 12 pixels. In the layers

palette, reduce opacity of the black & white layer to about 65 percent. Add another adjustment layer (Layer>New Adjustment Layer>Photo Filter), then vary the setting of the filter for a range of colored effects.

◼ Other Photoshop Operations
Straightening Verticals. One of the most amazing things Photoshop does is found under the Edit> Transform menu. Using these tools, you can correct architectural verticals in an image. Here's how:

Open your image make it smaller than the surrounding canvas area (you can do this by reducing the percentage view at the lower left of the image window, or by moving the slider in the Navigator

This subtle mix of sepia and black & white was created by Claude Jodoin using the technique described above.

Using the technique described above, Kevin Kubota removed all the color from this image except the yellow bouquet. The effect is extremely appealing.

window). Turn your rulers on (View>Rulers). Click on the horizontal or vertical ruler at the edge of the image and drag a rule into position, placing it on the edge of one of the crooked lines so you will be able to gauge when the line has been straightened.

Then, select the entire image (Select>All) and go to the transform function (Edit>Transform>Skew). When you do this, handles will appear on all four corners of the image. Holding down your Option key and dragging on one of the corner handles allows you to push or pull one edge independently of the others. By doing so, you can correct the vertical or horizontal lines within the image. When the lines are straight, press Return or Enter and the image will

process. Be sure not to skew the image details out of perspective.

Optical Lens Correction. You can also correct a wide range of common lens distortion flaws from a single interface in Photoshop CS2. You can eliminate barrel or pincushion distortion, chromatic aberration, vignetting, and perspective flaws in all three dimensions—and do it in one pass with simple, intuitive controls, a live preview, and an alignment grid.

Photoshop CS2's optical lens correction (Filter> Distort>Lens Correction) lets you remove distortion caused by either wide-angle lens use or bad perspective. This mini-applcation lets you correct verticals more easily than Free Transform. You can also:

- Use the zoom tool to magnify edges in the image if you want to easily correct chromatic aberration or vignetting, and the move-grid tool to adjust the alignment grid.
- Use the edge menu to determine how the edges of the transformed image are filled, or use the scale slider to expand the image and fill in the edges.
- Use the distortion tool to correct distortion by dragging in the image.
- Use the straighten tool or angle setting to straighten the image by rotation.

Making Contact Sheets. Photoshop has a fairly sophisticated method for making proof sheets. Simply go to File>Automate>Contact Sheet II. Choose a folder from which to make the proof sheets and select a resolution and color mode (RGB is the default mode). Select the size and font that you want the file names to appear in (or if you want to turn that feature off) and the number of rows and columns—3x3, 4x4, 2x3, etc. Hit OK and the contact sheets are produced automatically.

Liquify. Liquify is a separate application within Photoshop. The liquify filter lets you push, pull, rotate, reflect, pucker, and bloat any area of an image. The distortions you create can be subtle or drastic, which makes the command a powerful tool for retouching images as well as creating artistic effects.

The best way to control your results is to begin by making a selection with the lasso tool. Then go to Filter>Liquify. When your selection comes up, you'll see that it has a brush with a crosshair in it. In the panel to the right, you can adjust this brush size for more precise control. Gently push the area that you want to shrink or stretch, gradually working it until you form a clean line. When you're done, hit Enter. You will return to the original image with the

Here is an image that, because of the lighting and subject matter, was pretty lifeless. Claude Jodoin created a blank layer atop the background layer by clicking on the new layer icon. On that layer, he used the gradient tool to create a linear gradient—from blue on the top to orange on the bottom. He then changed the layer mode to saturation and adjusted the layer opacity until the colors were saturated but fairly representative. Photograph by Claude Jodoin.

Enhancing colors can be a simple matter of changing from sRGB to Adobe 1998 RGB, where the colors are more vivid. On top of that you can go to Hue/Saturation, under the Image>Adjustments>Hue/Saturation menu. Increase the saturation to bring out the raw color in the file. Photograph by Claude Jodoin.

selection still active—but with your modifications in place.

Sharpening. As most Photoshop experts will tell you, sharpening is the final step in working an image, and one of the most common flaws in an image is over-sharpening. Photoshop's sharpen filters are designed to focus blurry or softened images by increasing the contrast of adjacent pixels. This means that you can easily over-sharpen an image and compress detail out of an area or even the entire image.

The most flexible of Photoshop's sharpening tools is the unsharp mask filter (Filter>Sharpen>Unsharp Mask). In the unsharp mask dialog box, the amount field determines how much to increase the contrast of the pixels. The radius setting refers to the number of pixels surrounding the edge pixels that will be affected by the sharpening; a lower value sharpens only the edge pixels, whereas a higher value sharpens a wider band of pixels. The threshold setting is used to specify how different the sharpened pixels must be from the surrounding area before they are considered edge pixels and sharpened by the filter. The default threshold value (0) sharpens all the pixels in the image.

Single-Channel Sharpening

If you sharpen the image in the RGB composite channel, you are sharpening all three channels simultaneously. This can lead to color shifts and a degradation in quality. Instead, go to the channels palette and look at each channel individually. Sharpen the channel with the most midtones (usually the green channel, but not always), then turn the other two channels back on. This will produce a much finer rendition than sharpening all three channels.

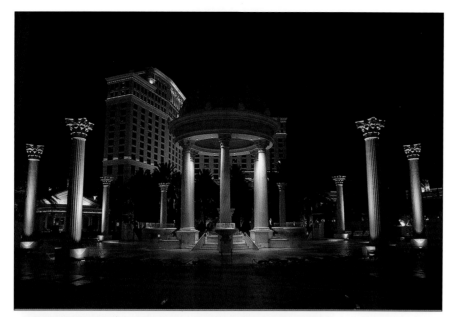

After applying optical lens correction, the surface-curving distortion caused by the wide-angle lens and low shooting angle are eliminated. The adjustable grid provides constant visual feedback, so you can easily tell when the horizontal and vertical surfaces in your shot are lined up properly.

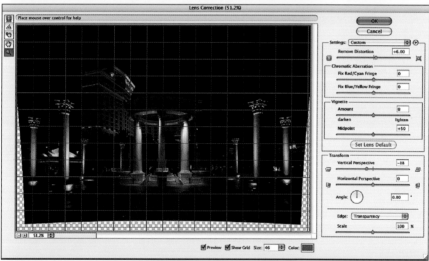

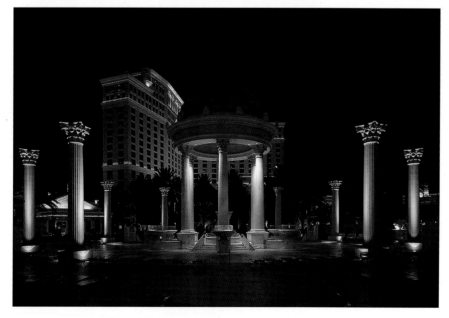

◼ Album Design

Design Templates. Martin Schembri has created a set of commercially available design templates that come on four different CDs and are meant to help photographers create elegant album-page layouts in Photoshop. The design templates are drag-and-drop tools, and four different palettes are available: traditional, classic, elegant, and contemporary. The tools are cross-platform, meaning that they can be used by Macs or PCs, and are customizable so that you can create any size or type of album with them. For more, visit www.martinschembri .com.au.

Color Sampling. One of Charles Maring's tricks of the trade is sampling colors from the images on his album pages in Photoshop. This is done by using Photoshop's eyedropper tool. When you click on an area, the eyedropper reveals the component colors in either CMYK or RGB in the color palette. He then uses those color readings for graphic elements on the page he designs for those photographs, producing an integrated, color-coordinated design on the album page. If using a page-layout program like Quark XPress or Adobe InDesign, those colors can be used at 100 percent or any lesser percentage for color

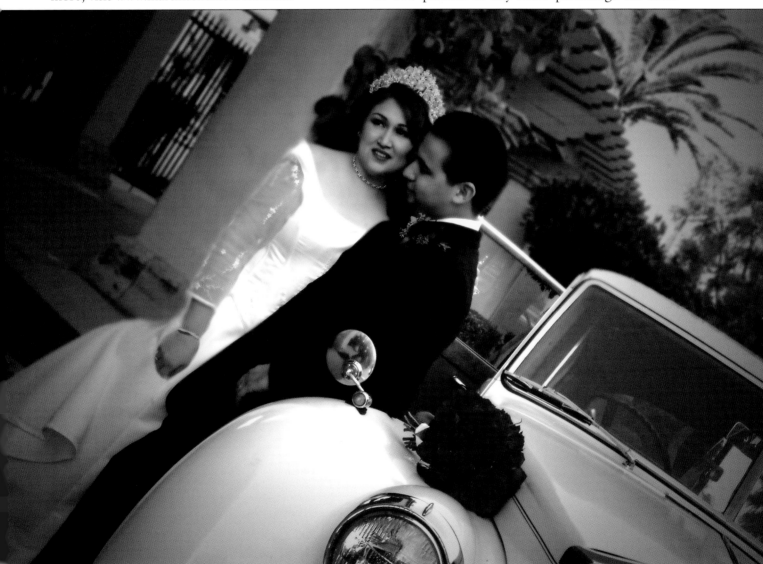

Jerry D, who specializes in digital makeovers, says his clients many times love the pictures but sometimes don't love themselves in the pictures. Jerry utilized many Photoshop tricks to get this image right. He selectively softened it, vignetted the image with a diffused colored vignette, and then the magic started. The bride asked him to make her slimmer, which he did by moving her arm closer to her body to mask the line of her torso. In this image, Jerry removed her arm in Photoshop and pasted it back onto her body, made thinner with the liquify filter. You cannot tell where the retouching was done and the bride was ecstatic over Jerry's magic.

LEFT—Claude Jodoin created this striking effect using the techniques described on pages 91 and 92. **FACING PAGE**—Martin Schembri's drag-and-drop templates for Photoshop make album design simple and elegant.

washes on the page or background colors that match the Photoshop colors precisely.

◼ Stair Interpolation

The best way to increase the size of images is to up-sample the image in small increments, otherwise known as stair interpolation. This method of up-sizing is preferable to increasing image size in one large step, say from 100 to 400 percent. The concept of stair interpolation is simple: rather than using the Image>Image Size command to go directly from 100 to 400 percent, you would use the image size com-mand numerous times, increasing the image size by perhaps 10 percent each time until you get the size you need.

Obviously, this can be tedious if your software does not have some automation capability. For this purpose, Fred Miranda (www.fredmiranda.com) offers SI Pro and Resize Pro, stair-interpolation plug-ins for Photoshop that are completely automated. You enter the size increase or the desired dimensions, specify sharpening or not, and the image is quickly enlarged—and almost indistinguishable from the original.

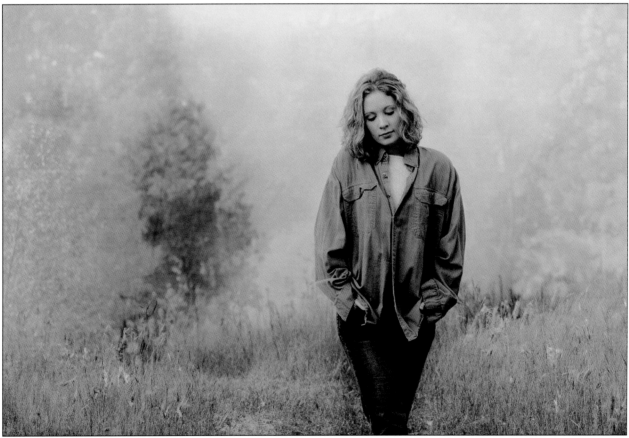

◘ The "Fuzzy Filter"

Fuzzy and Shirley Duenkel operate Duenkel Portrait Art, a successful studio in West Bend, WI. They began their business in the 1980s with weddings and have since evolved into a low-volume studio specializing in custom portraits that are created almost exclusively on-location and for high-school seniors.

Fuzzy studies the work of commercial photographers and cinematographers, gaining inspiration from television and magazine ads. He says, "With large budgets, art directors, and the constant push to create a look that sells, it's only logical that commercial shooters have usually been more on the cutting edge of creativity than portrait photographers. Therefore, it's wise to keep a close eye on what's new in fashion magazines and other media—especially when a significant part of your business is high-school senior portraits."

One photographic technique Fuzzy has adopted is a simple, low-saturation, high-contrast technique that looks great and which the senior kids seem to love. He calls it the "Fuzzy Filter." Here's the technique: duplicate the background layer and desaturate the top layer completely. In curves, click on the center and pull the line about one-fourth of the way to the left. Then, click on the curve about one-eighth of the way down and pull it down until just before it flattens against the bottom. Next, click on the curve near the top, and pull it down until the curve isn't flattened against the top. At this point the top layer will be a very light, high-contrast, black & white image. Reduce the opacity of the top layer to about 45 percent. You can stop there, or go on to an optional additional step. To give the image a little more punch, click on the history brush and stroke color back into the cheeks, lips, and eyes at an opacity setting of about 10 percent. Finally, flatten the image and save it with a different name (to distinguish it from the original). Fuzzy suggests saving these steps as an action for ease of use.

FACING PAGE, TOP—The original image was taken in the morning during fading fog. The sun was peeking over the horizon, providing enough of a low main light to give the lighting some direction. The surrounding fog added fill lighting. Photograph by Fuzzy Duenkel. **FACING PAGE, BOTTOM**—Here's the same image after the "Fuzzy Filter" was applied. This is a higher-contrast, lower-saturation technique that Fuzzy Duenkel observed in print and television advertising.

Jerry D is an award-winning wedding photographer from Upland, CA. For Jerry, the captured digital image is never the final product. I was lucky enough to sit in on a typical Photoshop session with him when he routinely "worked" an image to his liking. All in all, Jerry spent about 20 minutes on the image—and much of that time was spent explaining things to me and repeatedly saving in-progress versions of the image so we could show the sequence of steps.

Because Jerry employs so many after-image effects, he uses an Apple 23-inch HD monitor with its expanded resolution and size. This technological marvel makes ever using a CRT monitor again an impossibility. And, yes, he even talked this writer into getting one. Being able to see the nuances of retouching and image enhancement (and show two full-frame versions on a single screen) make this monitor a necessity, not a luxury.

Here is the original image made in late afternoon outside a public building in Riverside, CA. The image was made with a Canon 1Ds and wide-angle zoom at the 37mm setting. The ISO was 640, and the exposure was ¹⁄₃₀ second at f/4.6. The composition and pose are good, as is the light. Jerry cropped the image, taking out the distracting space to the right of the second column and cropping into the edge of the arch to the left. Now the subjects and the architecture are balanced and the couple is prominent.

In Photoshop, Jerry went to the Brightness/Contrast command; he boosted the contrast to add a little punch and lowered the brightness slightly to add mood. Enlarging the image of the couple reveals that the image is noisy and that it could stand some serious sharpening. Jerry prefers to do the sharpening at this stage of the image manipulation rather than waiting until the end, as is customary. He uses two custom actions from Fred Miranda (www.fredmiranda.com) called ISOx Pro and Intellisharpen. The former reduces undesirable noise naturally and without trace, keeping the detail intact. Intellisharpen is ideal for images captured at high ISOs. It sharpens the image without sharpening noise and artifacts, providing excellent results.

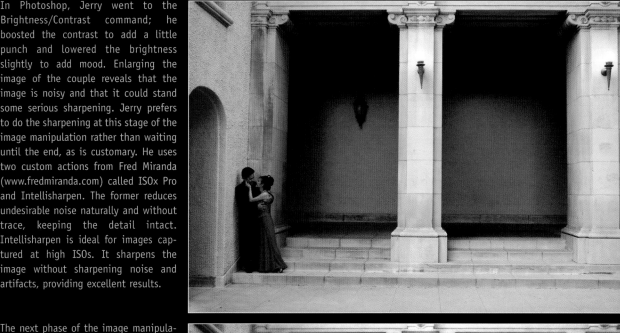

The next phase of the image manipulation involves using nik Color Efex plugins, in this case Monday Morning Sepia, which was used to bring out the texture in the stucco and create "serious" mood. First, Jerry duplicated the image so he could look at both files simultaneously on the monitor. Jerry adjusted the color of the sepia image using the color balance command (Image>Adjustments> Color Balance), adding red and a slight amount of green until he was happy with the color and depth of the sepia tone.

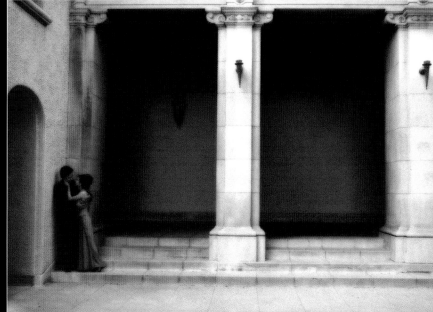

Using the move tool, Jerry clicked and dragged the image from the duplicated file on top of the original image, being careful to align it exactly. With the eraser tool set at 74-percent opacity and 68-percent flow, he began to erase the image of the couple, using a fairly large, soft-edged brush. Using lower opacity would let you bring up the underlying original image more gradually, but Jerry often needs to work on a hundred images at a sitting, so he has learned to work quickly. He uses two different techniques to reveal the image: fast clicks of the mouse over a wide area or a slow drag of the tool—especially along the edges of the couple. You can see that the image now is a combination of two images.

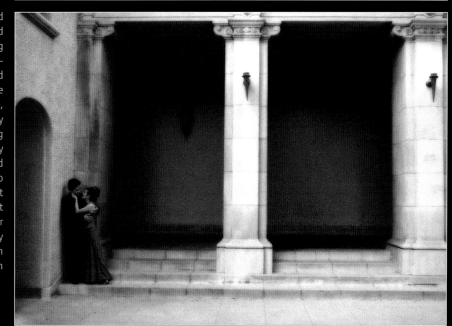

Jerry wanted to burn in parts of the image to reveal the texture of the stucco and the beautiful yellow color in the columns. Using the burn tool, a large brush, and an exposure of 25 percent, Jerry burned in the columns and steps, being careful not to make it look too even. A dappled uneven look works best. He burned a little more at the top of the columns to recapture intricate detail. Jerry uses a sponging motion with the mouse when burning in and works fairly slowly, undoing any area that gets overdone. The most interesting thing he did here was to burn in the shadows, which are almost black already. He burned in around the frame of the black rectangles, leaving the center untouched. Burning in the shadows, he says, creates mystery.

Jerry liked the image at this point but was not satisfied with the lights on the columns. Looking back at the original, you can see yellow orbs of light. Jerry wanted to restore that effect, so he used the elliptical marquee tool to create a circular selection. Using a brush that was larger than the selection, he set the foreground color to light yellow and applied the color to the selection. He added more color to the edges of the selection than the middle. He finished by selecting a small brush, selecting pure white as the foreground color, and placed white highlights within the light's center to give it dimension. He repeated the procedure for the second light.

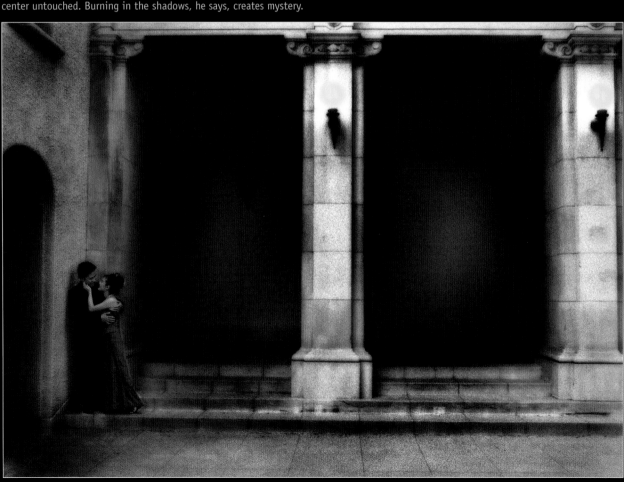

The final image.

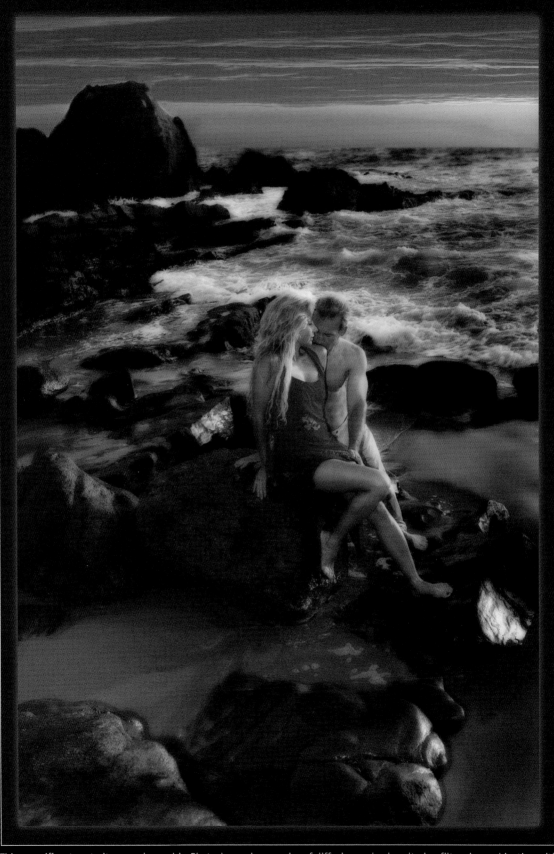

This magnificent portrait was enhanced in Photoshop using a series of diffusing and color-altering filters in combination with Photoshop's lighting effects.

Jerry D photographed young Australian photographer Ryan Schembri while he was visiting California. Jerry used a series of nik Multimedia filters to selectively enhance the grain and add selective diffusion throughout the image. The background of this image is Santa Monica, CA

Jerry D created this wonderful blue portrait by finding a great location and then handling the refinements well in Photoshop. He vignetted the image carefully and enhanced the blue color on the wall and sidewalk. He isolated the skin tones and kept them looking normal.

CRAIG KIENAST SEES SMOKE SIGNALS

Craig Kienast is constantly searching for new means of inspiration. One day he was photographing coffee beans and a cup of hot coffee for a client. To make the coffee look piping hot, he lit an incense stick and placed it behind the cup, then backlit the scene. The effect worked well and the client was happy, but the effect on Kienast was lasting. The more he looked at the different images of the smoke, the more he realized that each image had a different story to tell.

What Craig witnessed is called fluid dynamics, where each swirl, stream, and cloud of smoke takes on a life of its own and no two instants are the same. He decided to

This was another self-assignment for Craig Kienast, whose bread and butter is senior portraits with an edge. The image was created by wrapping the young girl in white tulle and lighting the scene from above to bring out the texture of the material. In Photoshop he split the image in half and transformed half of the face to match the other half. Next, he created a duplicate layer, added a 12-pixel Gaussian blur, and experimented with various layer-mode settings until this reddish effect was achieved.

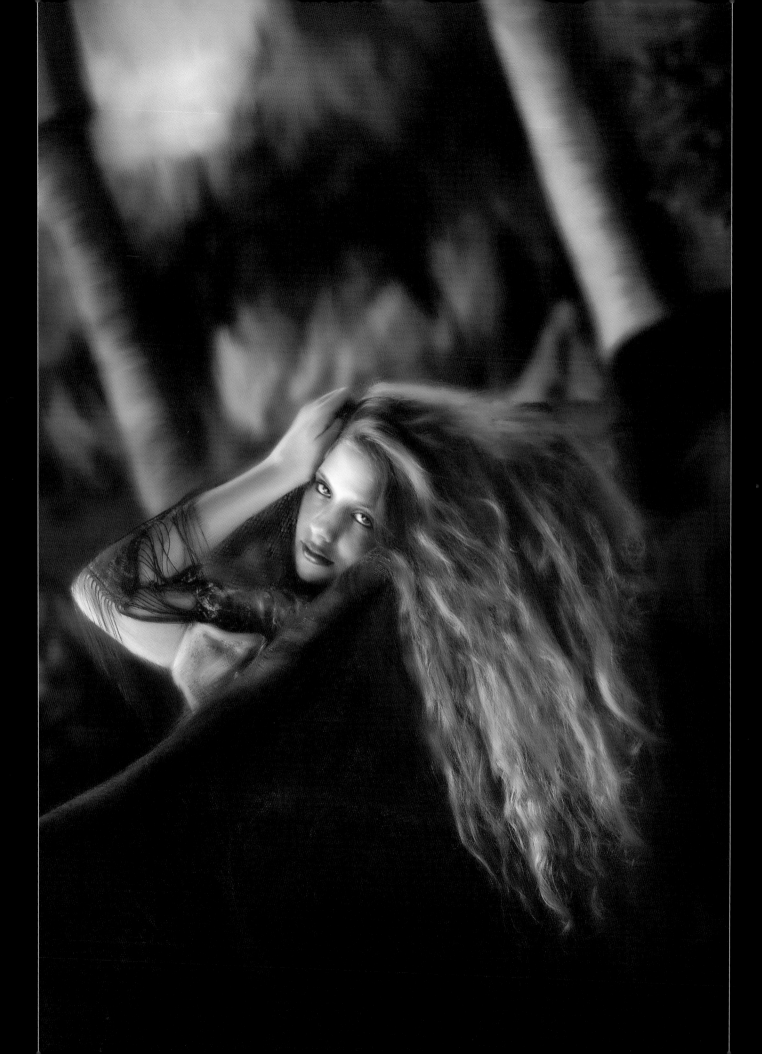

ake it to the next level, so one afternoon he set up his studio to backlight smoke. With plenty of incense sticks and stick matches on hand, he shot about four hundred still-life images.

After airing out the studio, the project took on a greater life as Photoshop came into play. He copied half

the image, pasted it back into the document, then flipped it horizontally—creating an image similar to the Rorschach inkblot tests psychiatrists use to analyze emotional and intellectual functioning and integration.

When treated this way, Kienast noticed he started to see familiar shapes emerging from the smoke—just as

ABOVE —One of Craig Kienast's fantastic "smoke signals" images.

FACING PAGE—Craig Kienast's senior portraits are quite inventive, relying on great lighting, a fair amount of Photoshop work, and strong diagonal lines. This senior had unusually long, wavy hair, which became the focal point of the series of images he made of her. She is illu-

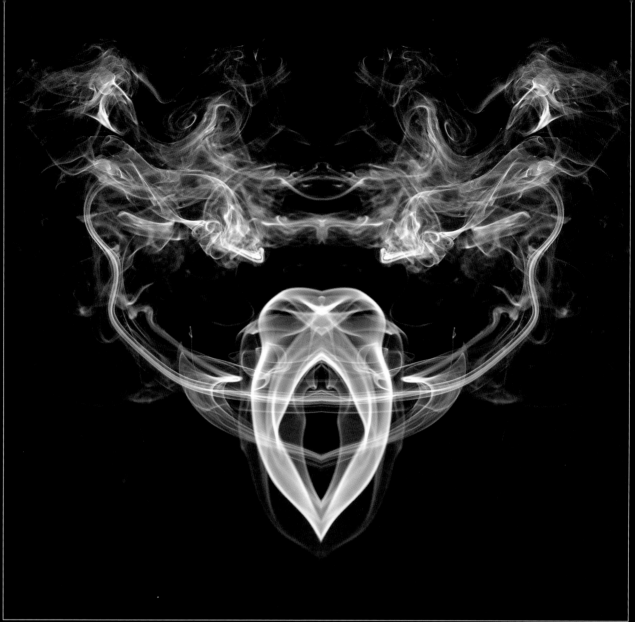

ABOVE AND RIGHT—Everyone seems to see something different in Craig Kienast's "smoke signals" images.

when your imagination lets you see all kinds of images in clouds. Additionally, the images seem to resemble different things to different people. Delighted at this result, Craig is currently preparing 25 art pieces for display from this 20-minute shoot. You can see more of Craig's images at www.photock.com.

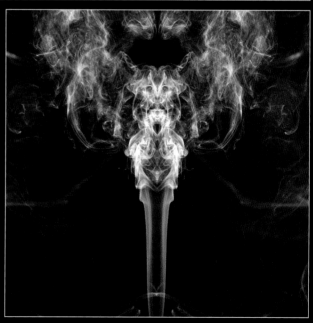

CONTRIBUTORS

Becker. Becker, who goes by only his last name, is a gregarious, likeable wedding photojournalist who operates a successful studio in Mission Viejo, CA. He has been a featured speaker at WPPI and has also competed and excelled in international print competition. Visit his website at www.thebecker.com.

David Beckstead. David Beckstead has lived in a small town in Arizona for over 20 years. With help from the Internet, forums, digital cameras, seminars, WPPI, Pictage, and his artistic background, his passion has grown into a national and international wedding-photography business. He refers to his style of wedding photography as artistic photojournalism.

Marcus Bell. Marcus Bell's creative vision, fluid, natural style, and sensitivity have made him one of Australia's most revered photographers. It's this talent, combined with his natural ability to make people feel at ease in front of the lens, that attracts so many of his clients. Bell's comprehensive portfolio of work clearly illustrates his natural flair and versatility. His work has been published in numerous magazines in Australia and overseas, including *Black & White, Capture, Portfolio Bride,* and countless other bridal magazines.

Joe Buissink. Joe Buissink is an internationally recognized wedding photographer from Beverly Hills, CA. Almost every bride-to-be who picks up a bridal magazine will have seen Buissink's exceptional images. He has photographed numerous celebrity weddings, including Jennifer Lopez's 2002 wedding, and is a multiple Grand Award winner in WPPI print competition.

Anthony Cava, BA, MPA, APPO. Born and raised in Ottawa, Ontario, Canada, Anthony Cava owns and operates Photolux Studio with his brother, Frank. Frank and Anthony's parents originally founded Photolux as a wedding/portrait studio 30 years ago. Anthony joined WPPI and the Professional Photographers of Canada 10 years ago. At one time, he was the youngest Master of Photographic Arts (MPA) in Canada. Cava won WPPI's Grand Award for the year with the first print that he ever entered in competition.

Gigi Clark. With four college degrees, Gigi Clark has a varied background including multimedia, instructional design, graphic design, and conceptual art. She brings all of her talents to her upscale photography business located in Southern California. She has received numerous awards and honors including several First Places in both PPA and WPPI competitions, as well as the first-time offered Fujifilm Award for Setting New Trends.

Mike Colón. Mike Colón is a celebrated wedding photojournalist from the San Diego, CA, area. Colón's work reveals his love for people and his passion for life. His natural and fun approach frees his subjects to be themselves, revealing their true personalities and emotions. His images combine inner beauty, joy, life, and love frozen forever in time. He has spoken before national audiences on the art of wedding photography.

Ctein. Ctein is one of the few remaining dye-transfer printers on the planet and the author of *Post Exposure: Advanced Techniques for the Photographic*

Printer (Focal Press, 2000). He has spent three decades in photo preservation and digital technology, and now these disciplines have merged into a business: Digital Photo Restoration by Ctein (www.photo-repair.com). He is also a master printer and has written for most (if not all) of the photographic publications in existence. Readers may see more of his work and read a sample chapter of his book at his website: www.plaidworks.com/ctein/.

Jerry D. Jerry D owns and operates Enchanted Memories, a successful portrait and wedding studio in Upland, CA. He has had several careers in his lifetime—from licensed cosmetologist to black-belt martial arts instructor. Jerry has been highly decorated by WPPI and won many national awards since joining the organization.

Jim DiVitale, M.Photog, MEI, Cr, API, F-ASP. Jim DiVitale has been an Atlanta commercial advertising photographer and an instructor for over 25 years. His award-winning digital photography has been featured in *Graphis Photo, Print, Archive, Creativity, Photo Electronic Imaging, Digital Output Magazine, Digital Imaging, Rangefinder,* and *Photo District News.* Jim has lectured before audiences at Seybold, Photo Plus, MAC Design, Imaging USA, HOW Design, WPPI, and World Council of Professional Photographers. He has also authored several Adobe Photoshop training CDs with Software Cinema that are shown at Photoshop training expos across United States and Europe. His clients include IBM, BP Amoco, Mizuno USA, Genuine Parts Company, Witness Systems, JP Morgan Financial, TEC America, Coca-Cola USA, and Scientific Atlanta. See more of Jim's work at www.DiVitalePhoto.com

Fuzzy and Shirley Duenkel. Fuzzy and Shirley Duenkel began photographing weddings in 1975. Almost 20 years later, Fuzzy started entering prints in Wisconsin PPA competition and was subsequently awarded many Courts of Honor, four Fuji Masterpiece Awards, and 18 Traveling Loans for Wisconsin. He has been ranked as one of the top-five portrait photographers in the state ever since. Since 1993, Fuzzy has won the top awards for the Wisconsin PPA senior folio competition six times. Fuzzy was also 1996 and 1997 Photographer of the Year for the Southeastern Wisconsin PPA. In addition, he has had 15 prints selected for National Traveling Loan Collection, two for Disney's Epcot Center, one for Photokina in Germany, and one for the International Hall of Fame and Museum in Oklahoma.

Don Emmerich, M.Photog., M.Artist, M.EI, Cr., CEI, CPPS. Don Emmerich is a virtuoso of the visual arts and one of the pioneers of applied photographic digital imaging. He belongs to a select group of professionals who have earned all four photographic degrees, and was chosen to be a member of the exclusive Camera Craftsmen of America Society, comprised of the 40 top portrait photographers in the United States. Don has been PPA's Technical Editor for the past 12 years, with some 150 articles published in various magazines, both nationally and internationally.

Jeff and Kathleen Hawkins. Jeff and Kathleen Hawkins operate a high-end wedding and portrait photography studio in Orlando, FL. They have authored several books, including *Professional Marketing & Selling Techniques for Wedding Photographers* (2001) and *Professional Techniques for Digital Wedding Photography* (2nd ed., 2004), both published by Amherst Media. Jeff Hawkins has been a professional photographer for over twenty years. Kathleen Hawkins holds a masters degree in business administration and is past president of the Wedding Professionals of Central Florida (WPCF) and past affiliate vice president for the National Association of Catering Executives (NACE). Visit their website at: www.jeff hawkins.com.

Glenn Honiball. Glenn Honiball is the ultimate Photoshop practioner. His clients are ad agencies—the most prestigious ones—from around the world. He has worked for the likes of: J. Walter Thompson, Optic Nerve, Brainstorm, Saatchi & Saatchi, and

Zig, to name a few. Companies he's worked for include such big names as Ford, GE, BMW, Coke, Sony, Kraft Foods and the NFL. At this writing Glenn Honiball is working on a new book, *Commercial Photoshop Retouching: In the Studio* (O'Reilly, 2005). For a look at 80 of Glenn's befores and afters, visit his web site: www.retouch.ca.

Claude Jodoin. Claude Jodoin is an award-winning photographer from Detroit, MI. He has been involved in digital imaging since 1986 and has not used film since 1999. He is an event specialist and also shoots numerous weddings and portrait sessions throughout the year. You can e-mail him at claudej1 @aol.com.

Craig Kienast. Craig Kienast has been involved in photography in one form or another since 1985 but didn't really get excited about it until the advent of digital. With imagination and a keen sense of marketing, he was the originator of Fantasia Art Prints, a wild form of imagery popular with seniors that uses Photoshop and Painter techniques combined with elegant lighting. Working in the small town of Clear Lake, IA, Kienast ordinarily gets more than double the fees of his nearest competitor. Samples of Craig's work as well as his teaching materials can be seen on his website, www.photock.com.

Brian King. Brian King began accumulating awards for his artwork in elementary school. He attended the Ohio Institute of Photography, graduating in 1994. Earning both his Certified Professional Photographer and Master of Photography degrees from PPA, he is a member of PPO-PPA, Senior Photographers International, and The American Society of Photographers. Brian joined Root Studios in 2004 and is currently photographing in their new 5300 square-foot Hilliard, OH, studio.

Kevin Kubota. Kevin Kubota formed Kubota Photo-Design in 1990 as a solution to stifled personal creativity. The studio shoots a mixture of wedding, portrait, and commercial photography. Kubota Photo-Design was one of the early pioneering studios of pure digital wedding photography in the late 1990s, and Kubota was soon widely acclaimed for his his teaching, training other photographers to make a successful transition from film to digital. He is the author of *Digital Photography Boot Camp* (Amherst Media, 2006).

John Lund. John Lund has a lucrative career making hilarious images of dogs and cats. His greeting card line, "Animal Antics," published by Portal Publications, features cats and dogs lounging in swimming pools, doing the tango, having their hair done, and even practicing the sport of sumo wrestling. His photographs can also be seen on posters, calendars, jigsaw puzzles, and stationery. His latest book is *Adobe Masterclass Photoshop Compositing with John Lund* (Peachpit Press, 2004). He also has authored some very popular books including *Animal Antics* (Andrews McMeel, 2002) and *Animal Wisdom* (Andrews McMeel, 2004). His website is www.johnlund.com.

Kersti Malvre. After a long and successful career in the fashion and cosmetics industries, award-winning artist Kersti Malvre discovered the world of hand-painted photography. Since 1995, she has been devoted to this art form. She is now recognized as one of the top photographic artists in the country and holds the PPA Photographic Craftsman's degree for outstanding contributions to the portrait photography profession.

Charles and Jennifer Maring. Charles and Jennifer Maring own Maring Photography, Inc. in Wallingford, CT. Charles is a second-generation photographer, his parents having operated a successful studio in New England for many years. His parents now operate Rlab (www.resolutionlab.com), a digital lab that does all of the work for Maring Photography, as well as for other discriminating photographers in need of high-end digital work. Charles Maring is the winner of the WPPI 2001 Album of the Year Award. His work was recently featured in *People* magazine, which ran six pages of his images from the Star Jones wedding.

Bruno Mayor. Bruno Mayor is a third-generation French photographer living in Corsica. He is a member of the French trade union of photographers, the GNPP (Grouping National of the Professional Photographers), and recently finished second overall in the French National portrait competition. You can see more of Bruno's images at his website: www.espaceimage.com.

Craig Minielly, MPA, SPA. Craig Minielly is the owner and operator of AURA Photographics, a totally digital photography studio servicing the Canadian market for the last 18 years. Craig is currently on the PPOC National Exhibition Committee and is the National Accreditation Chairman for PPOC. He is a three-time Ontario Photographer of the Year, British Columbia Photographer of the Year finalist, and six-time Canadian Photographer of the Year finalist. His Photoshop actions are widely regarded as some of the best and most creative plug-ins available. His website is www.craigsactions.com.

Rich Nortnik, Jr. Educated in fine arts, Rich Nortnik, Jr. is considered to be one of the world's foremost experts in Photoshop. In the last five years, he has been awarded numerous design and digital-illustration awards and has even been christened an official "Photoshop Guru." As senior designer/illustrator for the Shaw Group, one of the world's largest engineering and construction firms, he has designed artwork and illustrations for transportation projects all over the world. Visit Rich Nortnik Jr.'s website at www.richnortnikjr.com.

Parker Pfister. Parker Pfister, who shoots weddings locally in Hillsboro, OH, as well as in neighboring states, is quickly developing a national celebrity. He is passionate about what he does and can't imagine doing anything else (although he also has a beautiful portfolio of fine-art nature images). Visit him at www.pfisterphoto-art.com.

Ray Prevost. Ray Prevost is a microbiologist who worked for 27 years as a medical technician in the Modesto, CA, area. He has always been interested in photography, but it wasn't until his two daughters were in college that he decided to open up his studio full time. In 1992, he received certification from PPA, and after four years of submitting prints, received his Master Photographer degree in 1996. Ray is a member of Stanislaus Professional Photographers, Professional Photographers of California, PPA, and WPPI.

Martin Schembri, M.Photog. AIPP. Martin Schembri has been winning national awards in his native Australia for 20 years. He has achieved a Double Master of Photography with the Australian Institute of Professional Photography. He is an internationally recognized portrait, wedding, and commercial photographer and has conducted seminars on his unique style of creative photography all over the world.

Tim Schooler. Tim Schooler Photography is an award-winning studio specializing in high-school senior portrait photography with a cutting-edge style. Tim's outstanding work has been published internationally in magazines and books. His studio is located in Lafayette, LA. See Tim's outrageous portfolio of senior images at his website: www.tim schooler.com.

Jeff Smith. Jeff Smith is an award-winning senior photographer from Fresno, CA. He owns and operates two studios in Central California and is well recognized as a speaker on lighting and senior photography. He is the author of *Corrective Lighting, Posing, and Retouching for Digital Portrait Photographers* (Amherst Media, 2005), *Senior Contracts* (self-published), and *Outdoor and Location Portrait Photography* (Amherst Media, 2003). He can be reached at his website, www.jeffsmithphoto.com.

David Clark Wendt. After years of shooting traditional commercial work and stock photography, Cincinnati, OH, photographer David Clark Wendt has found his niche in self-publishing calendars of fast-moving and slick cars. He has also produced award-winning calendars on 18-wheelers and steam locomotives. An entrepreneur, Wendt started with the bare minimum print run of 5000 calendars and is

now printing 40,000 a year. His work can be purchased in Borders and other popular bookstores. His work can be seen at www.wendtworldwide.com.

Bryan White. Bryan White, studio owner and portrait artist, has viewed the world through a camera lens since the age of 12, when his father gave him a Minolta 35mm camera. Using his degree in fine art to explore other artistic mediums, Bryan and his wife, Blayne, opened Whitelake Studio in 1993, where his unique style of photography has become increasingly in demand. His work has won numerous awards from the most respected professionals in the country at state, regional, and national levels—including many of the coveted Kodak Gallery and Fuji Masterpiece Awards. Since beginning to compete in 1999, his work has been consistently honored in the National Loan Collection and the ASP Traveling Loan Collection, and has been displayed by Kodak at Disney's Epcot Center.

David Anthony Williams, M.Photog., FRPS, AOPA. David Anthony Williams owns and operates a wedding studio in Ashburton, Victoria, Australia. In 1992, he achieved the rare distinction of receiving Associateship and Fellowship of the Royal Photographic Society of Great Britain (FRPS) on the same day. Through the annual Australian Professional Photography Awards system, Williams achieved the level of Master of Photography with Gold Bar—the equivalent of a double master. In 2000, he was awarded the Accolade of Outstanding Photographic Achievement from WPPI and was a Grand Award winner at their annual conventions in both 1997 and 2000.

Yervant Zanazanian, M. Photog. AIPP, F.AIPP. Yervant was born in Ethiopia, lived and studied in Italy, then settled in Australia 25 years ago. His passion for photography and the darkroom began at a very young age, when he worked after school at a photography business run by his father, photographer to Emperor Hailé Silassé of Ethiopia. Yervant currently owns one of the most prestigious photography studios of Australia and services clients both nationally and internationally. His awards are too numerous to mention, but he has been Australia's Wedding Photographer of the Year three of the past four years.

GLOSSARY

Action. In Adobe Photoshop, a series of commands that you play back on a single file or a batch of files.

Adobe Camera RAW. The Photoshop Camera RAW plug-in lets you open a camera's RAW image file directly in Photoshop without using another program to convert the camera RAW image into a readable format. As a result, all your work with camera RAW image files can be completely done in Photoshop.

Adobe DNG. Adobe Digital Negative (DNG) is a publicly available archival format for the RAW files generated by digital cameras. By addressing the lack of an open standard for the RAW files created by individual camera models, DNG helps ensure that photographers will be able to access their files in the future.

Adobe RGB 1998. The largest recommended RGB working space. Well suited for print production with a broad range of colors. Widest gamut color space of working RGBs.

Antialiasing. Refers to methods of eliminating or reducing unwanted artifacts such as jagged lines. In the context of images, antialiasing refers to the reduction of the jagged borders between colors.

Bit. Stands for binary digit. Smallest unit of information handled by a computer. One bit is expressed as a 1 or a 0 in a binary numeral. A single bit conveys little information a human would consider meaningful. However, a group of eight (8) bits makes up a byte, representing more substantive information.

Bit Depth. Number of bits (smallest units of information handled by a computer) per pixel allocated for storing color information in an image file.

Burning In. A darkroom or computer printing technique in which specific areas of the image are given additional exposure in order to darken them.

Byte. A unit of data, typically consisting of eight bits. Computer memory and storage are referenced in bytes—kilobytes (KB=1000 bytes), megabytes (MB=1 million bytes), or gigabytes (GB=1 trillion bytes).

Calibration. The process of altering the behavior of a device so that it will function within a known range of performance or output.

CCD (Charge-Coupled Device). A type of image sensor that separates the spectrum of color into red, green, and blue for digital processing by the camera. A CCD captures only black & white images. The image is passed through red, green, and blue filters in order to capture color.

CF Card. CompactFlash (CF) cards are popular memory cards developed by SanDisk in 1994 that uses solid-state memory to store data on a very small card.

CF Card Reader. A device that is used to connect a CF card or Microdrive to a computer. CF card

readers are used to download digital image files from a capture and/or storage device to your computer workstation.

Channel. Used extensively in Photoshop, channels are images that use grayscale data to portray image components. Channels are created whenever you open a new image and accessed in the channels palette. The image's color mode determines the number of color channels created. For example, an RGB image has four default channels: one for each of the red, green, and blue primary colors, plus a composite channel used for editing the image. Additional channels can be created in an image file for such things as masks or selections.

Chromatic Aberration. A common lens defect in which the lens focuses different frequencies (colors) of light differently. One type of chromatic aberration results in the different colors being in focus, but each color's image point at a slightly different size. This type of aberration results in complementary color fringing in areas away from the center of the image.

CMOS (Complementary Metal Oxide Semiconductor). A type of semiconductor that has been, until the Canon EOS D30, widely unavailable for digital cameras. CMOS imaging chips offer more integration (more functions on the chip), lower power dissipation (at the chip level), and smaller system size as compared to CCD (charge-coupled device), the other major type of imaging chip.

CMYK. In Photoshop's CMYK mode, each pixel is assigned a percentage value for each of the process inks. The lightest (highlight) colors are assigned small percentages of process ink colors, the darker (shadow) colors are assigned higher percentages. For example, a bright red might contain 2 percent cyan, 93 percent magenta, 90 percent yellow, and 0 percent black. In CMYK images, pure white is generated when all four components have values of 0 percent.

Color Management. A system of software-based checks and balances that ensures consistent color through a variety of capture, display, editing, and output device profiles.

Color Space. An environment referring to the range of colors that a particular device is able to produce.

Color Temperature. The degrees Kelvin (K°) of a light source or film sensitivity. Color films are balanced for 5500°K (daylight), 3200°K (tungsten), or 3400°K (photoflood).

Cross Processing. With film, developing color negative film in color transparency chemistry (or vice versa). With digital, a Photoshop effect that mimics film cross processing.

Curves. Changing the shape of the curve in the curves dialog box alters the tonality and color of an image. In the RGB mode, bowing the curve upward lightens an image; bowing the curve downward darkens it. The steeper sections of the curve represent portions of an image with more contrast. Conversely, flatter sections of the curve represent areas of lower contrast in an image.

Dodging. Darkroom or computer printing technique in which specific areas of the print are given less print exposure, making them lighter.

DPI (Dots Per Inch). Printer resolution is measured by the number of ink dots per inch (dpi) produced by all laser printers, including imagesetters. Inkjet printers produce a microscopic spray of ink, not actual dots; however, most inkjet printers have an approximate resolution of 300 to 2880dpi.

E.I. (Exposure Index). The term refers to a film speed other than the rated ISO of the film.

Embedding. Including a color profile as part of the data within an image file. Color space, for example, is an embedded profile.

Emulation Profiles. Characteristic settings used in RAW file converters to emulate certain types of film or other image effects.

EPS (Encapsulated PostScript). File format capable of containing high-quality vector *and* bitmap graphics, including flexible font capabilities. The EPS format is supported by most graphic, illustration, and page-layout software.

EXIF (Exchangeable Image Format). EXIF is a digital imaging standard for storing metadata, such as camera settings and other text, within digital image files. EXIF data is found under File>File Info in Photoshop.

Feathering. In Photoshop, spreading the selection over a wider area so as to minimize the apparent edge of the selected area.

FireWire. A high-speed interface designed to transfer data at speeds of 800MB and higher. FireWire technology transfers data uncompressed in real time.

Flashing. A darkroom technique used in printing to darken an area of the print by exposing it to raw light. The same technique can be achieved in Photoshop using a transparent vignette.

Flashmeter. A handheld incident light meter that measures both the ambient light of a scene and, when connected to an electronic flash, will read flash only or a combination of flash and ambient light. They are invaluable for determining outdoor flash exposures and lighting ratios.

FTP (File Transfer Protocol). A means of opening a portal on a website for direct transfer of large files or folders to or from a website.

Gamut. Fixed range of color values reproducible on a display (e.g., monitor) or output (e.g., printer) device. Gamut is determined by the color gamut, which refers to the actual range of colors, and the dynamic range, which refers to the brightness values.

Gaussian Blur. Filter used to blur a selection by an adjustable amount. Gaussian refers to the bell-shaped curve that is generated when Photoshop applies a weighted average to the pixels. The Gaussian blur filter adds low-frequency detail and can produce a hazy effect.

Gradient Map. A command that maps the equivalent grayscale range of an image to the colors of a specified gradient fill. If you specify a two-color gradient fill, for example, shadows in the image map to one of the endpoint colors of the gradient fill, highlights map to the other endpoint color, and midtones map to the gradations in between.

Grayscale. Color model consisting of up to 254 shades of gray plus absolute black and absolute white. Every pixel of a grayscale image displays as a brightness value ranging from 0 (black) to 255 (white). The exact range of grays represented in a grayscale image can vary.

Highlight Brilliance. Refers to the specularity of highlights on the skin. An image with good highlight brilliance shows specular highlights (paper base white) within a major highlight area. Achieved through good lighting and exposure techniques.

Histogram. A graph associated with a single image file that indicates the number of pixels that exist for each brightness level. The range of the histogram represents 0 to 255 from left to right, with 0 indicating "absolute" black and 255 indicating "absolute" white.

Hot Spots. (1) A highlight area of the image file that is overexposed and without detail. Sometimes these areas are etched down to a printable density. (2) The center of the core of light that is often brighter than the edges of the light's core.

ICC Profile. File that contains device-specific information that describes how the device behaves toward color density and color gamut.

Since all devices communicate differently as far as color is concerned, profiles enable the color management system to convert device-dependent colors into or out of each specific color space based on the profile for each component in the workflow. ICC profiles can utilize a device-independent color space to act as a translator between two or more different devices.

Incident Light Meter. A handheld light meter that measures the amount of light falling on its light-sensitive dome.

Interpolation. When an image is resampled, an interpolation method is used to assign color values to any new pixels Photoshop creates, based on the color values of existing pixels in the image. For interpolation, choose one of the following options: bilinear for a medium-quality method; bicubic for the slow but more precise method, resulting in the smoothest tonal gradations; bicubic smoother when you're enlarging images; and bicubic sharper for reducing the size of an image. This method maintains the detail in a resampled image. It may, however, oversharpen some areas of an image. In this case, try using bicubic.

JPEG (Joint Photographic Experts Group). JPEG is an image file format with various compression levels. The higher the compression rate, the lower the image quality, when the file is expanded (restored). Although there is a form of JPEG that employs lossless compression, the most commonly used forms of JPEG employ lossy compression algorithms, which discard varying amounts of the original image data in order to reduce file storage size.

LCD (Liquid Crystal Display). On digital SLRs, the LCD is used to display images and data.

Levels. In Photoshop, levels allows you to correct the tonal range and color balance of an image. In the levels dialog box, input refers to the original intensity values of the pixels in an image and output refers to the revised color values that are based on your adjustments.

Lossy/Lossless Files. Many file formats use compression to reduce the file size of bitmap images. Lossless techniques compress the file without removing image detail or color information; lossy techniques remove detail.

LPI (Lines Per Inch). Also known as screen ruling or line screen, screen frequency is measured in lines per inch (lpi) or lines of cells per inch in a halftone screen. The higher an output device's resolution, the finer (higher) a screen ruling you can use. The relationship between image resolution and screen frequency determines the quality of detail in the printed image. To produce a halftone image of the highest quality, you generally use an image resolution that is two times the screen frequency.

Mask. In Photoshop, an adjustment tool that sits atop a layer, allowing you to isolate areas of an image as you apply color changes, filters, or other effects to the unmasked part of the image. When you select part of an image, the area that is not selected is "masked" or protected from editing.

Metadata. Metadata (literally, data about data) preserves information about the contents, copyright status, origin, and history of documents, and can be used to search for files.

Microdrive. Storage medium for portable electronic devices using the CF Type II industry standard. Current Microdrive capacities range from 340MB to 1GB of storage. The benefit of a Microdrive is high storage capacity at a low cost. The downside is the susceptibility to shock—bumping or dropping a Microdrive has been known to lead to data loss.

Noise. Extraneous visible artifacts that degrade image quality. Image noise is made up of lumi-

nance (grayscale) noise, which makes an image look grainy, and chroma (color) noise, which is usually visible as colored artifacts in the image. Photographing with a higher ISO can result in images with objectionable noise. Luminance smoothing reduces grayscale noise, while color noise reduction reduces chroma noise.

PC Card Adapter. Device used to connect your CF card or Microdrive to your computer. Used to download image files from a capture and/or storage device to your computer workstation.

Pixel (Picture Element). Smallest element used to form an image on a screen or paper. Thousands of pixels are used to display an image on a computer screen or print an image from a printer.

Plug-Ins. Software programs developed by Adobe and by other software developers in conjunction with Adobe Systems to add features to Photoshop. A number of importing, exporting, and special-effects plug-ins come with Photoshop; they are automatically installed inside the plug-ins folder.

PPI (Pixels Per Inch). Image file resolution is measured in pixels per inch. A typical high-resolution file is 300ppi.

Print Driver. Software that translates data from a device, usually a computer, into instructions that a specific printer uses to create a graphical representation of that data on paper or other media.

Profiling. Method by which the color reproduction characteristics of a device are measured and recorded in a standardized fashion. Profiles are used to ensure color consistency throughout the workflow process.

PSD (Photoshop Document). The default file format in Photoshop and the only format that supports all Photoshop features. The PSD format saves all image layers created within the file.

RAW File. File format that uses lossless compression algorithms to record picture data directly from the sensor without applying any in-camera corrections. In order to use images recorded in the RAW format, files must first be processed by compatible software. RAW processing includes the option to adjust the exposure, white balance, and color of the image while leaving the original RAW picture data unchanged.

Resolution. The number of pixels or dots per inch. When printed, higher-resolution images can reproduce more detail and subtler color transitions than lower-resolution images because of the density of the pixels in the images.

RGB (Red, Green, and Blue). Computers and other digital devices handle color information as shades and combinations of red, green, and blue. A 24-bit digital camera, for example, will have 8 bits per channel in red, green, and blue, resulting in 256 shades of color per channel.

Sharpening. In Photoshop, filters that increase apparent sharpness by increasing the contrast of adjacent pixels in an image.

Soft Proof. An on-screen preview of the document colors as they will be reproduced on a specified device.

sRGB. Color-matching standard jointly developed by Microsoft and Hewlett-Packard. Cameras, monitors, applications, and printers that comply with this standard are able to reproduce colors the same way. Also known as a color space designated for digital cameras. sRGB is suitable for RGB images destined for the web but not recommended for print production work, according to Adobe.

TIFF (Tagged Image File Format). File format commonly used for image files. TIFF files are lossless, meaning that no matter how many times they are opened and closed, the data remains the same (unlike JPEG files, which are

designated as lossy files, meaning that data is lost each time the files are opened and closed).

Unsharp Mask. A sharpening filter in Adobe Photoshop that is usually the last step in preparing an image for printing.

USB/USB 2.0 (Universal Serial Bus). An external bus standard that supports data transfer rates of 12MB per second. USB is particularly well suited for high-speed downloading of images from your digital camera straight to your computer. USB 2.0 transfers data at a much greater rate than USB, with a 480MB-per-second rate in a dedicated USB 2.0 port.

Vignette. A semicircular, soft-edged border around the main subject. Vignettes can be either light or dark in tone and can be included at the time of shooting or created later in printing.

White Balance. The camera's ability to correct color and tint when shooting under different lighting conditions, including daylight, indoor, and fluorescent lighting.

Working Color Space. Predefined color-management settings specifying the color profiles to be associated with the RGB, CMYK, and Grayscale color modes. The settings also specify the color profile for spot colors in a document. Central to the color management workflow, these profiles are known as working spaces. The working spaces specified by predefined settings represent the color profiles that will produce the best color fidelity for several common output conditions.

INDEX

CREATIVE LIGHTING TECHNIQUES FOR STUDIO PHOTOGRAPHERS, 2nd Ed.

Dave Montizambert

Whether you are shooting portraits, cars, tabletop, or any other subject, Dave Montizambert teaches you to take control of your lighting. $29.95 list, 8½x11, 120p, 80 color photos, order no. 1666.

POSING AND LIGHTING TECHNIQUES FOR STUDIO PHOTOGRAPHERS

J. J. Allen

Master the skills you need to create beautiful lighting for portraits. Posing techniques help turn portraits into works of art. $29.95 list, 8½x11, 120p, 125 color photos, order no. 1697.

CORRECTIVE LIGHTING, POSING & RETOUCHING FOR
DIGITAL PORTRAIT PHOTOGRAPHERS, 2nd Ed.

Jeff Smith

Learn to make every client look his or her best by using lighting and posing to conceal real or imagined flaws—from baldness, to acne, to figure flaws. $34.95 list, 8½x11, 120p, 150 color photos, order no. 1711.

TRADITIONAL PHOTO-GRAPHIC EFFECTS WITH ADOBE® PHOTOSHOP®, 2nd Ed.

Michelle Perkins and Paul Grant

Use Photoshop to enhance your photos with handcoloring, vignettes, soft focus, and much more. Step-by-step instructions are included for each technique for easy learning. $29.95 list, 8½x11, 128p, 150 color images, order no. 1721.

MASTER POSING GUIDE FOR PORTRAIT PHOTOGRAPHERS

J. D. Wacker

Learn to pose single portrait subjects, couples, and groups for studio or location portraits. Includes techniques for photographing weddings, teams, children, special events, and much more. $29.95 list, 8½x11, 128p, 80 photos, order no. 1722.

THE ART OF COLOR INFRARED PHOTOGRAPHY

Steven H. Begleiter

Color infrared photography will open the doors to a new and exciting photographic world. This book shows readers how to previsualize the scene and get the results they want. $29.95 list, 8½x11, 128p, 80 color photos, order no. 1728.

BEGINNER'S GUIDE TO ADOBE® PHOTOSHOP®, 2nd Ed.

Michelle Perkins

Learn to effectively make your images look their best, create original artwork, or add unique effects to any image. Topics are presented in short, easy-to-digest sections that will boost confidence and ensure outstanding images. $29.95 list, 8½x11, 128p, 300 color images, order no. 1732.

PROFESSIONAL TECHNIQUES FOR
DIGITAL WEDDING PHOTOGRAPHY, 2nd Ed.

Jeff Hawkins and Kathleen Hawkins

From selecting equipment, to marketing, to building a digital workflow, this book teaches how to make digital work for you. $29.95 list, 8½x11, 128p, 85 color images, order no. 1735.

LIGHTING TECHNIQUES FOR
HIGH KEY PORTRAIT PHOTOGRAPHY

Norman Phillips

Learn to meet the challenges of high key portrait photography and produce images your clients will adore. $29.95 list, 8½x11, 128p, 100 color photos, order no. 1736.

PROFESSIONAL DIGITAL PHOTOGRAPHY

Dave Montizambert

From monitor calibration, to color balancing, to creating advanced artistic effects, this book provides those skilled in basic digital imaging with the techniques they need to take their photography to the next level. $29.95 list, 8½x11, 128p, 120 color photos, order no. 1739.

PROFESSIONAL SECRETS OF
NATURAL LIGHT PORTRAIT PHOTOGRAPHY

Douglas Allen Box

Use natural light to create hassle-free portraiture. Beautifully illustrated with detailed instructions on equipment, lighting, and posing. $29.95 list, 8½x11, 128p, 80 color photos, order no. 1706.

LIGHTING AND EXPOSURE TECHNIQUES FOR
OUTDOOR AND LOCATION PORTRAIT PHOTOGRAPHY

J. J. Allen

Meet the challenges of changing light and complex settings with techniques that help you achieve great images every time. $29.95 list, 8½x11, 128p, 150 color photos, order no. 1741.

WEDDING PHOTOGRAPHY
WITH ADOBE® PHOTOSHOP®

Rick Ferro and Deborah Lynn Ferro

Get the skills you need to make your images look their best, add artistic effects, and boost your wedding photography sales with savvy marketing ideas. $29.95 list, 8½x11, 128p, 100 color images, index, order no. 1753.

WEB SITE DESIGN
FOR PROFESSIONAL
PHOTOGRAPHERS

Paul Rose and Jean Holland-Rose

Learn how to design, maintain, and update your own photography web site—attracting new clients and boosting your sales. $29.95 list, 8½x11, 128p, 100 color images, index, order no. 1756.

PROFESSIONAL PHOTOGRAPHER'S GUIDE TO
SUCCESS IN
PRINT COMPETITION

Patrick Rice

Learn from PPA and WPPI judges how you can improve your print presentations and increase your scores. $29.95 list, 8½x11, 128p, 100 color photos, index, order no. 1754.

PHOTOGRAPHER'S GUIDE TO
WEDDING ALBUM
DESIGN AND SALES

Bob Coates

Enhance your income and creativity with these techniques from top wedding photographers. $29.95 list, 8½x11, 128p, 150 color photos, index, order no. 1757.

PROFESSIONAL TECHNIQUES FOR
PET AND ANIMAL
PHOTOGRAPHY

Debrah H. Muska

Adapt your portrait skills to meet the challenges of pet photography, creating images for both owners and breeders. $29.95 list, 8½x11, 128p, 110 color photos, index, order no. 1759.

THE BEST OF
PORTRAIT PHOTOGRAPHY

Bill Hurter

View outstanding images from top professionals and learn how they create their masterful images. Includes techniques for classic and contemporary portraits. $29.95 list, 8½x11, 128p, 200 color photos, index, order no. 1760.

DIGITAL PHOTOGRAPHY
FOR CHILDREN'S AND
FAMILY PORTRAITURE

Kathleen Hawkins

Discover how digital photography can boost your sales, enhance your creativity, and improve your studio's workflow. $29.95 list, 8½x11, 128p, 130 color images, index, order no. 1770.

PROFESSIONAL STRATEGIES
AND TECHNIQUES FOR
DIGITAL PHOTOGRAPHERS

Bob Coates

Learn how professionals—from portrait artists to commercial specialists—enhance their images with digital techniques. $29.95 list, 8½x11, 128p, 130 color photos, index, order no. 1772.

LIGHTING TECHNIQUES FOR
LOW KEY PORTRAIT
PHOTOGRAPHY

Norman Phillips

Learn to create the dark tones and dramatic lighting that typify this classic portrait style. $29.95 list, 8½x11, 128p, 100 color photos, index, order no. 1773.

PORTRAIT PHOTOGRAPHY
THE ART OF SEEING LIGHT

Don Blair with Peter Skinner

Learn to harness the best light both in studio and on location, and get the secrets behind the magical portraiture captured by this award-winning, seasoned pro. $29.95 list, 8½x11, 128p, 100 color photos, index, order no. 1783.

THE DIGITAL DARKROOM
GUIDE WITH ADOBE®
PHOTOSHOP®

Maurice Hamilton

Bring the skills and control of the photographic darkroom to your desktop with this complete manual. $29.95 list, 8½x11, 128p, 140 color images, index, order no. 1775.

COLOR CORRECTION AND
ENHANCEMENT WITH
ADOBE® PHOTOSHOP®

Michelle Perkins

Master precision color correction and artistic color enhancement techniques for scanned and digital photos. $29.95 list, 8½x11, 128p, 300 color images, index, order no. 1776.

INTO YOUR DIGITAL DARKROOM STEP BY STEP

Peter Cope

Make the most of every image—digital or film—with these techniques for photographers. Learn to enhance color, add special effects, and much more. $29.95 list, 8½x11, 128p, 300 color images, index, order no. 1794.

LIGHTING TECHNIQUES FOR
FASHION AND GLAMOUR PHOTOGRAPHY

Stephen A. Dantzig, PsyD.

In fashion and glamour photography, light is the key to producing images with impact. With these techniques, you'll be primed for success! $29.95 list, 8½x11, 128p, over 200 color images, index, order no. 1795.

WEDDING AND PORTRAIT PHOTOGRAPHERS' LEGAL HANDBOOK

N. Phillips and C. Nudo, Esq.

Don't leave yourself exposed! Sample forms and practical discussions help you protect yourself and your business. $29.95 list, 8½x11, 128p, 25 sample forms, index, order no. 1796.

POWER MARKETING FOR WEDDING AND PORTRAIT PHOTOGRAPHERS

Mitche Graf

Set your business apart and create clients for life with this comprehensive guide to achieving your professional goals. $29.95 list, 8½x11, 128p, 100 color images, index, order no. 1788.

BEGINNER'S GUIDE TO PHOTOGRAPHIC LIGHTING

Don Marr

Create high-impact photographs of any subject with Marr's simple techniques. From edgy and dynamic to subdued and natural, this book will show you how to get the myriad effects you're after. $29.95 list, 8½x11, 128p, 150 color photos, index, order no. 1785.

POSING FOR PORTRAIT PHOTOGRAPHY

A HEAD-TO-TOE GUIDE

Jeff Smith

Author Jeff Smith teaches surefire techniques for fine-tuning every aspect of the pose for the most flattering results. $29.95 list, 8½x11, 128p, 150 color photos, index, order no. 1786.

PROFESSIONAL MODEL PORTFOLIOS

A STEP-BY-STEP GUIDE FOR PHOTOGRAPHERS

Billy Pegram

Learn how to create dazzling portfolios that will get your clients noticed—and hired! $29.95 list, 8½x11, 128p, 100 color images, index, order no. 1789.

MASTER LIGHTING GUIDE

FOR PORTRAIT PHOTOGRAPHERS

Christopher Grey

Efficiently light executive and model portraits, high and low key images, and more. Master traditional lighting styles and use creative modifications that will maximize your results. $29.95 list, 8½x11, 128p, 300 color photos, index, order no. 1778.

PROFESSIONAL DIGITAL IMAGING FOR WEDDING AND PORTRAIT PHOTOGRAPHERS

Patrick Rice

Build your business and enhance your creativity with practical strategies for making digital work for you. $29.95 list, 8½x11, 128p, 200 color photos, index, order no. 1780.

PROFITABLE PORTRAITS

THE PHOTOGRAPHER'S GUIDE TO CREATING PORTRAITS THAT SELL

Jeff Smith

Learn how to design images that are precisely tailored to your clients' tastes—portraits that will practically sell themselves! $29.95 list, 8½x11, 128p, 100 color photos, index, order no. 1797.

PROFESSIONAL TECHNIQUES FOR
BLACK & WHITE DIGITAL PHOTOGRAPHY

Patrick Rice

Digital makes it easier than ever to create black & white images. With these techniques, you'll learn to achieve dazzling results! $29.95 list, 8½x11, 128p, 100 color photos, index, order no. 1798.

DIGITAL PHOTOGRAPHY BOOT CAMP

Kevin Kubota

Kevin Kubota's popular workshop is now a book! A down-and-dirty, step-by-step course in building a professional photography workflow and creating digital images that sell! $34.95 list, 8½x11, 128p, 250 color images, index, order no. 1809.